COMEDY WILDLIFE
PHOTOGRAPHY AWARDS
VOL.4

First published in the UK by John Blake Publishing
an imprint of Bonnier Books UK
4th Floor, Victoria House
Bloomsbury Square
London WC1B 4DA
England

Owned by Bonnier Books
Sveavägen 56, Stockholm, Sweden

www.facebook.com/johnblakebooks
twitter.com/jblakebooks

First published in hardback in 2022

Hardback ISBN: 978-1-78946-655-3

British Library Cataloguing-in-Publication Data:
A CIP catalogue record for this book is available from the British Library.

Design by www.envydesign.co.uk
Front cover image: Arthur J.Telle
Back cover image: Brigitte Alcalay Marcon

Printed and bound in Lithuania

1 3 5 7 9 10 8 6 4 2

Text copyright © Paul Joynson-Hicks and Tom Sullam, 2022
All images © individual photographers
Captions by Nathan Joyce

John Blake Publishing is an imprint of Bonnier Books UK

COMEDY WILDLIFE

PHOTOGRAPHY AWARDS

VOL.4

CREATED BY
PAUL JOYNSON-HICKS AND TOM SULLAM

jb

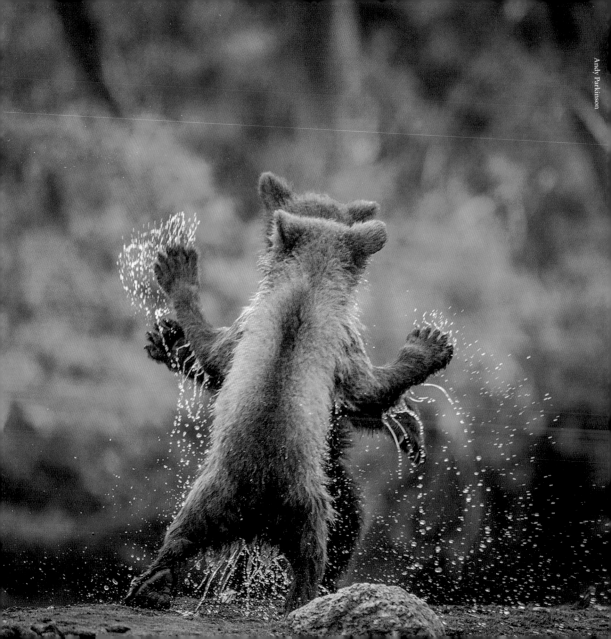

FOREWORD

BY KATE HUMBLE, AUTHOR, PRESENTER AND WILDLIFE EXPERT

Seven years ago, two photographers called Paul and Tom asked me if I would consider being a judge of a new wildlife photography competition they were starting up. 'Aren't there already quite a lot of photography competitions dedicated to wildlife?' I said, doubtfully, to which they replied, 'Not like this one!' I then had to admit my main worry, which was that I am a rubbish photographer and therefore entirely unsuitable as a judge. Undaunted, they asked, 'Do you like a good laugh?' and I admitted that I do. 'Then you're perfect,' they said. 'Because there will be people with the right know-how to judge the photographs' technical merits. All you have to do is tell us if they are funny.'

And so, every year since, I have looked forward to judging day because it is always a day of much laughter and hilarity. But it is also a reminder of just how incredibly diverse and weird and truly wonderful our natural world is. And it has turned out that combining wildlife and comedy has proved to be more than a bit of fun. From small beginnings, the competition now attracts photographers and press attention from all over the world and that has allowed The Comedy Wildlife Photography Awards to be a serious force for good.

The money raised, through sales of prints and things like this book, goes right back to grassroots conservation, helping to ensure that future generations will still have wild places to enjoy, wildlife to wonder at and many, many reasons to laugh.

Money from the sales of this book will directly help the incredible work of Whitley Fund for Nature. Started thirty years ago by Edward Whitley – who I freely admit is my hero – Whitley Fund for Nature set out to help fund the work of scientists, conservationists and educators who are tackling conservation issues on their home turf. I am an ambassador for WFN and over the years have had the great privilege to meet many of the people it has supported. I can honestly tell you that this now global network of extraordinary individuals gives all of us cause for hope and optimism. The work they do to protect and restore vital wildlife habitats, bring species back from the brink as well as engaging with and supporting local people, is a truly holistic, all-encompassing approach to conservation that has proved and continues to prove enormously effective. The Whitley Fund for Nature is exactly that – a fund, donated by a number of generous families and individuals. The charity itself is tiny, its running costs minimal, so donations really do go where they are most needed.

And we really do need our natural world. The simple fact is we can't survive without it. And apart from anything else, it has been proved by any number of scientific studies over the decades that nature really is good for us: good for our mental and physical well-being. It is no wonder that during the years of the pandemic, with all its associated anxieties and uncertainties, people looked to nature for solace. Nature and laughter. Because science has also proved that laughter really is the best medicine.

Comedy + wildlife. It's all we really need. Now go and enjoy a good laugh!

Kate Humble

INTRODUCTION – CONSERVATION THROUGH COMEDY

Who would have predicted that seven years after a whimsical thought in the foothills of Mount Meru (Tanzania), we would be sitting in the foothills of the South Downs, writing an introduction to our fourth (!!!!) collection of hilarious wildlife images? We can answer that question very easily: nobody in their right mind would have predicted this outcome. Certainly not Paul, who had the original whim, nor Tom, who was dragged into the affair by Paul, nor Michelle, who was similarly hustled into the little management team.

Much like the group name for giraffes – a journey of giraffe – this latest collection of wonderfully upbeat, positive, and engaging images comes because of a journey that none of us had expected to be on. Clichéd as this will sound, it stemmed from a small, fun idea, with small ambitions, that has grown into the wildly popular, global-reaching photography competition that has engaged literally hundreds of millions of people, and all for one common purpose: to raise awareness of the plight of wildlife. Sorry, for two common purposes. To raise awareness, yes, and, secondly, to help create positive change through action by people like you reading this book.

The journey and its direction have not been expected, nor has the team been architects of this journey. Essentially mirroring the slightly unrefined attention to detail that is true of Tom and Paul (using collective nouns again, these two would be closer to a confusion of wilderbeest), the competition has thrown its eager directors left, right and centre, tried to buck them off, skidded haphazardly away from the tracks and jumped over fences. But thanks to Michelle, the reins have stayed firmly in our grasp, just about...and the upshot? A totally unplanned but wild and exhilarating thrill. Furthermore, it has been one with so many extraordinary benefits. The warmth, laughter and loyalty we receive from those who come across the imagery is difficult to put into words – whether it be the global media, the one-person blogger, the local photography club, photographers, wildlife fans, celebrities etc., they all combine to create an energy that keeps us going. It keeps us believing that there is always a positive way of broaching negative topics. Certainly, there is a place for more direct, shocking imagery to grab attention and hopefully action...but, and it's a big but, we are totally convinced that positive reaction arises from positive promotion.

In the film *Gladiator*, Oliver Reed has a moment that strikes a chord with us when he says, 'win the crowd, and you will win your freedom'. Forgive us for drifting here, but there is a point to this filmic reference. We are not looking for freedom, as we are sure you know, but we are looking to win the attention of many, and through the many we will be able to effect a change in behaviour, however small. This change, whatever it may be – whether it is putting flower boxes on your windowsill for the bees, or not mowing areas of your gardens to let the wildflowers grow, or directly reducing your carbon emissions – will have direct impacts and benefits on the wildlife that lives on earth alongside us. Behavioural change is a choice only the individual can make, but we want to help get the individuals to that place. So, to bastardise Oliver Reed's line, our line is more like, 'win the crowd, and the crowd will win the fight to save wildlife'. (*Not yet copyrighted, but it will be. Or maybe not. Need to run it by the team first.*)

Onwards and upwards then. That can be our only direction now, following steady growth in entries, coverage and feedback, all suggesting that we have a long way to go on this journey. The fight to spread our word will continue, as will our endeavours to reach photographers without whom this competition and its goals would be somewhat weakened! Thank you to all you photographers who capture these wonderful life-affirming images, images that create immediate empathy, which we know is the fundamental driver of the actions taken to reduce the risk to wildlife. Thank you also to you, the reader, for making it this far in the text, but more importantly for buying this book. As a result of your purchase you are making a direct donation to our chosen charity this year – Whitley Fund for Nature. A fantastic charity, a fantastic approach to conservation, biodiversity and sustainability, and a fantastic team that we hope to work closely with for many years to come.

Enjoy! Laugh! Smile! Cry if you must! And ultimately spread the word!

Tom, Paul and Michelle

X

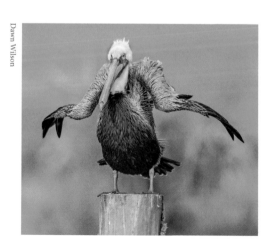
Dawn Wilson

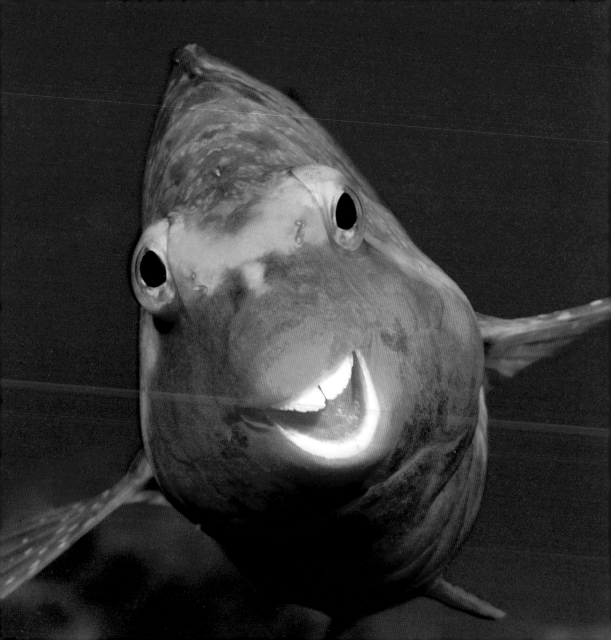

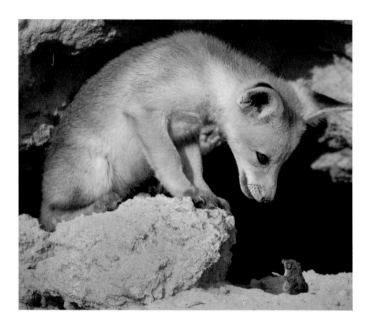

ANIMALS: Fox and Shrew
LOCATION: ISRAEL
I don't care how big you are, mate, you're not coming
in without ID.
PHOTOGRAPHER: Ayala Fishaimer

ANIMAL: Parrot Fish
LOCATION: EL HIERRO, CANARY ISLANDS
Dory hoped the tooth whitening would distract from her nasty
sunburn.
PHOTOGRAPHER: Arthur J. Telle

ANIMALS: Dwarf Mongoose

LOCATION: LAKE BOGORIA, KENYA

If you go down in the woods today, you're sure of a big surprise!

PHOTOGRAPHER: Asaf Sereth

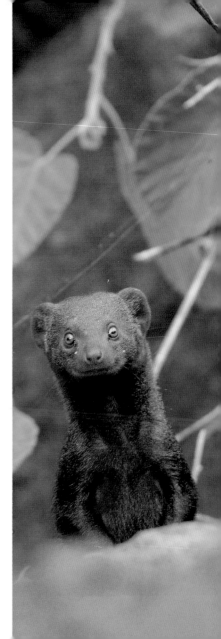

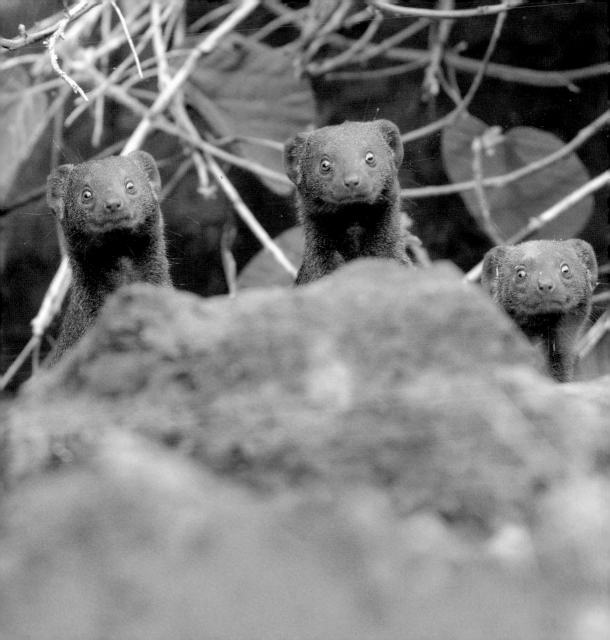

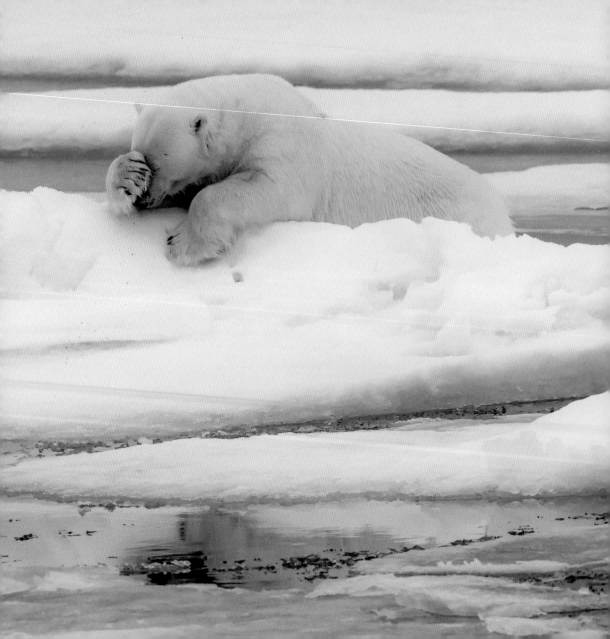

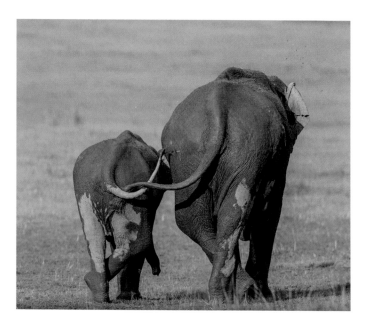

ANIMALS: Asian Elephant
LOCATION: CORBETT NATIONAL PARK, INDIA
Remember what Mummy taught you. You have to hold my tail when you're crossing the savanna during stampede season.
PHOTOGRAPHER: Jagdeep Rajput

ANIMALS: Polar Bear
LOCATION: SPITZBERG
Yup – I left the oven on at home. Nightmare.
PHOTOGRAPHER: Jacques Poulard

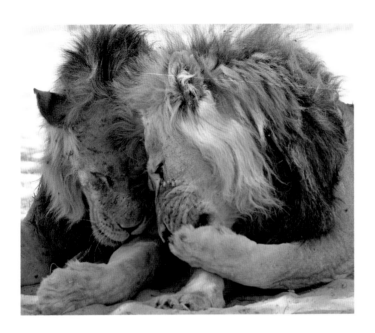

ANIMALS: African Lion
LOCATION: KALAHARI DESERT
POLICE REPORT: "I swear to you, Mufasa's been wearing a false
mane, all this time!"
PHOTOGRAPHER: Bernhard Esterer

ANIMALS: Giraffes
LOCATION: ETOSHA NATIONAL PARK, NAMIBIA
You finally nail the serious LinkedIn profile picture and then some
berk photobombs you.
PHOTOGRAPHER: Brigitte Alcalay Marcon

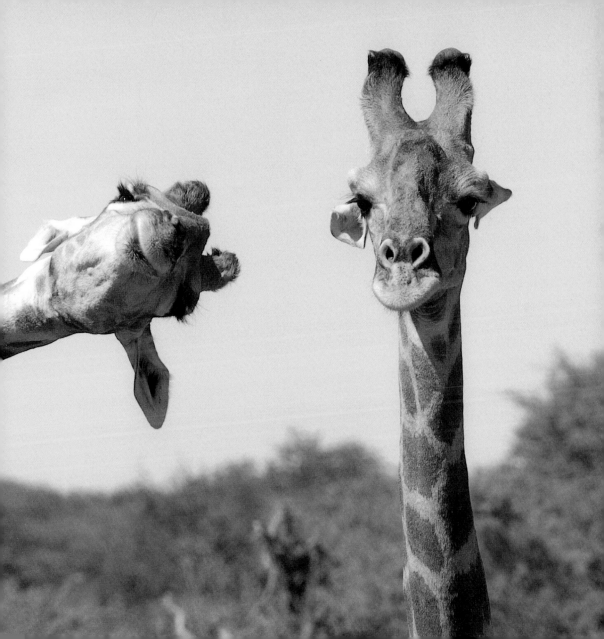

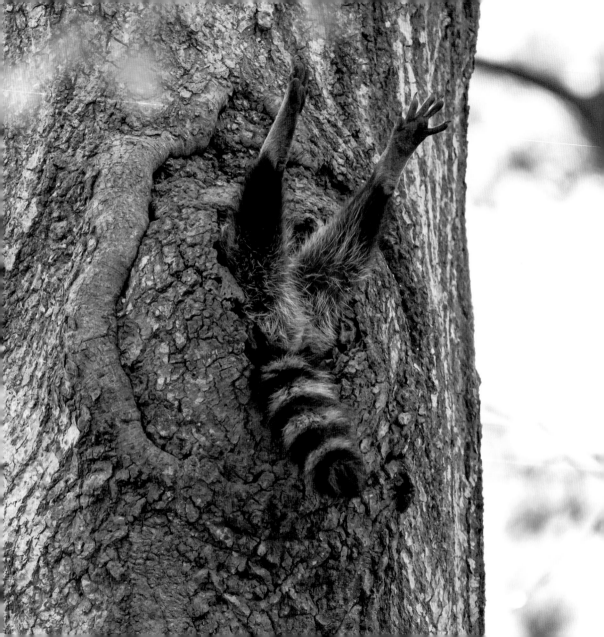

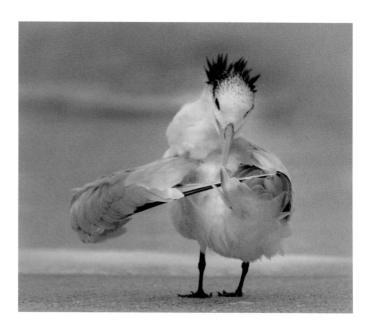

ANIMAL: Tern
LOCATION: FLORIDA
Tail feathers make excellent guitar strings, and my beak works
well as a pecktrum.
PHOTOGRAPHER: Danielle D'Ermo

ANIMAL: Racoon
LOCATION: NEWPORT NEWS, VA, USA
Lockdown workout sessions certainly were a little more challenging
than usual.
PHOTOGRAPHER: Charlie Davidson

ANIMALS: Gentoo Penguins
LOCATION: FALKLAND ISLANDS
Stag dos really are the same for all animals on Brighton Beach.
PHOTOGRAPHER: Christina Holfelder

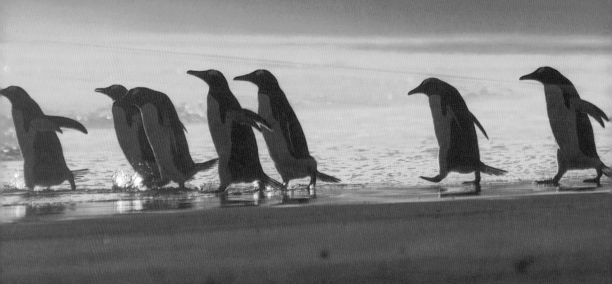

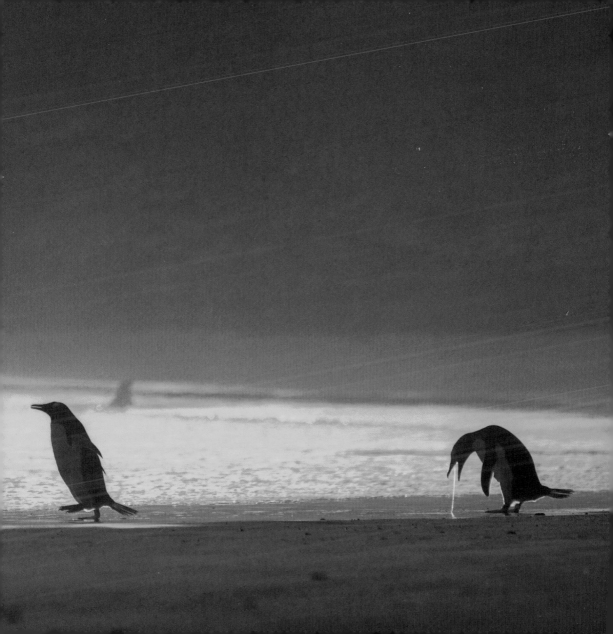

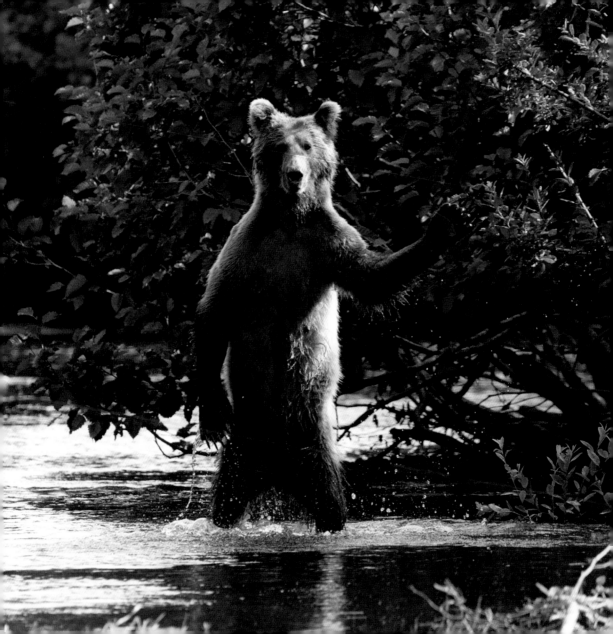

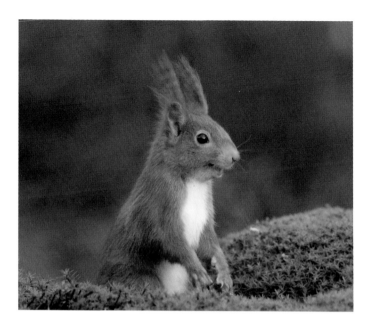

ANIMAL: Red Squirrel
LOCATION: ESPELO, THE NETHERLANDS
The expression of someone who's farted and got away with it
because the wind's travelling in the right direction.
PHOTOGRAPHER: Femke van Willigen

ANIMAL: Brown Bear
LOCATION: ALASKA
Well the sat nav did say "Bear Left".
PHOTOGRAPHER: Eric Fisher

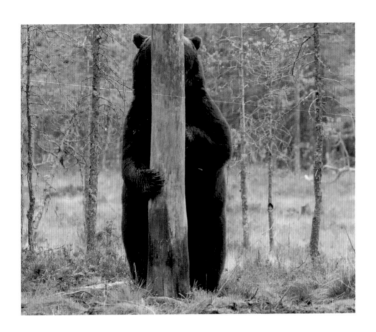

ANIMAL: Brown Bear

LOCATION: KUHMO, EAST FINLAND

Hide and seek just wasn't the game it used to be after the lockdown weight gain.

PHOTOGRAPHER: Esa Ringbom

ANIMAL: Reddish Egret

LOCATION: FORT DESOTO, FLORIDA

So what have I learned? Never try and eat a whole palm tree again...

PHOTOGRAPHER: Gail Bisson

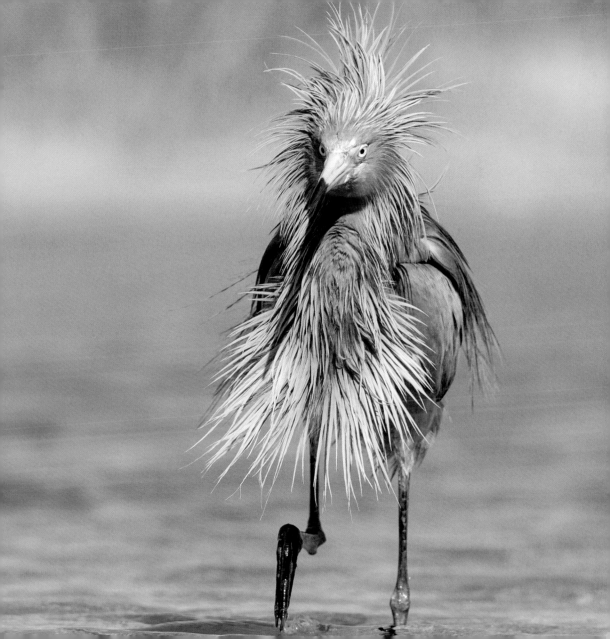

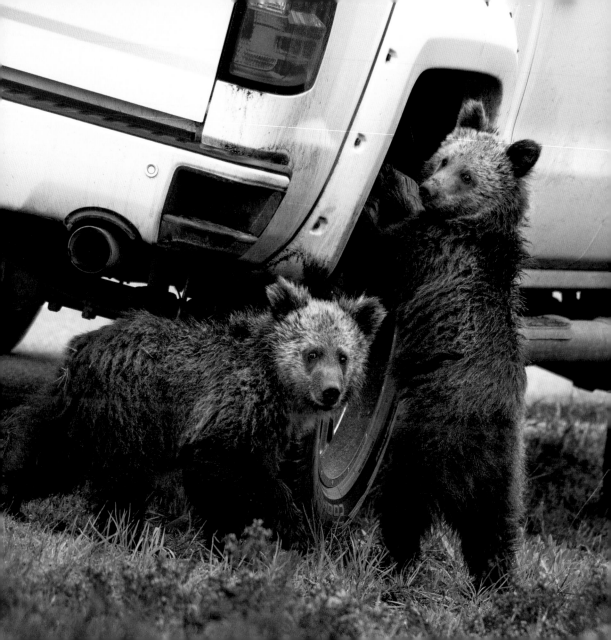

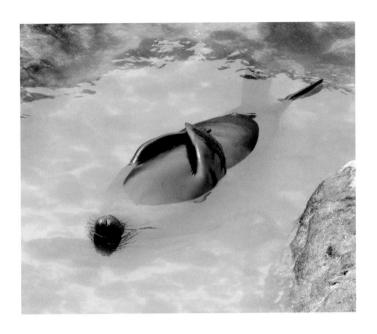

ANIMAL: Sea Lion
LOCATION: GALAPAGOS ISLANDS
Well that's going to make for unusual tan lines, but this chap
hasn't got a care in the world!
PHOTOGRAPHER: Sue Hollis

ANIMALS: Grizzly Bears
LOCATION: GRAND TETON NATIONAL PARK, USA
Things sure do look different since the AA started outsourcing their
breakdown recovery teams.
PHOTOGRAPHER: Kay Kotzian

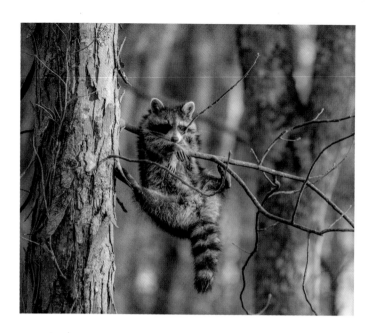

ANIMAL: Racoon
LOCATION: JACKSON, OHIO, USA
The Cross-palmed Bottom Salutation is only for advanced yoga practioners.
PHOTOGRAPHER: Jill Neff

ANIMAL: Royal Bengal Tiger
LOCATION: RANTHAMBORE NATIONAL PARK, INDIA
"Someone pass me the Anadin" mumbeld a tender-headed Shere Khan.
PHOTOGRAPHER: Jagdeep Rajput

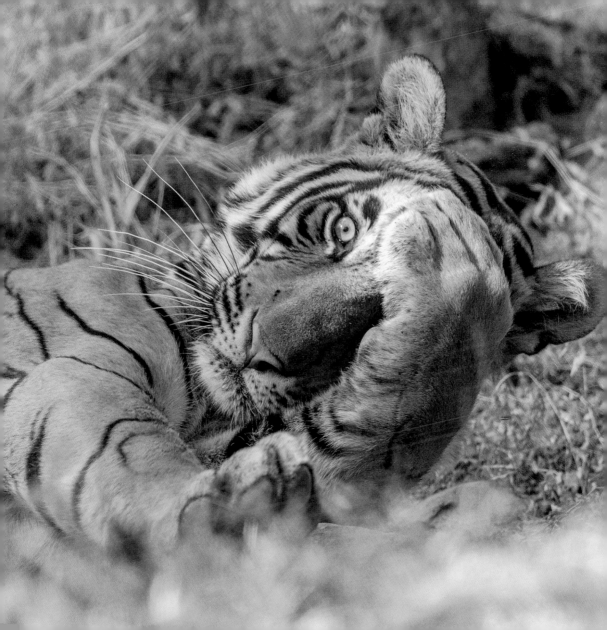

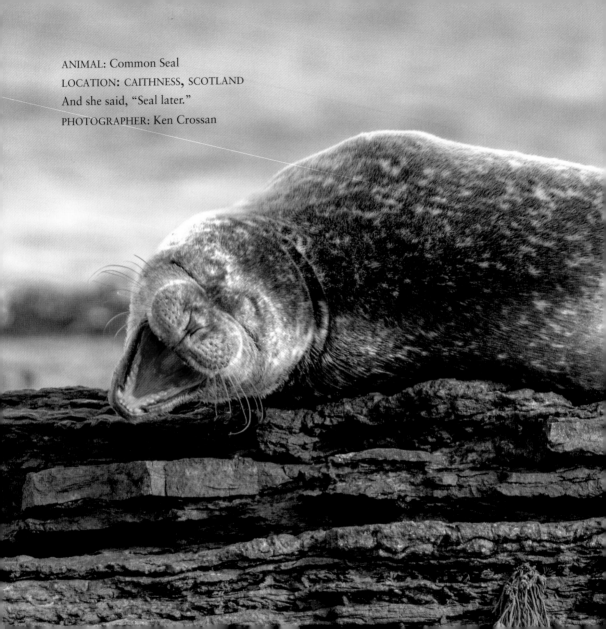

ANIMAL: Common Seal
LOCATION: CAITHNESS, SCOTLAND
And she said, "Seal later."
PHOTOGRAPHER: Ken Crossan

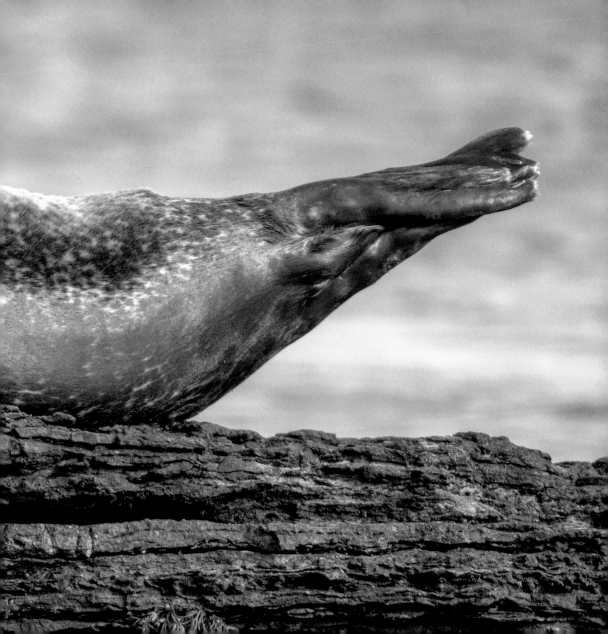

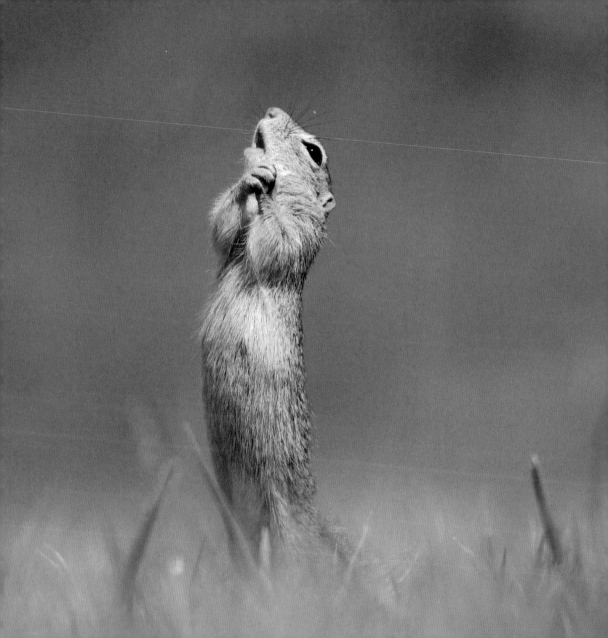

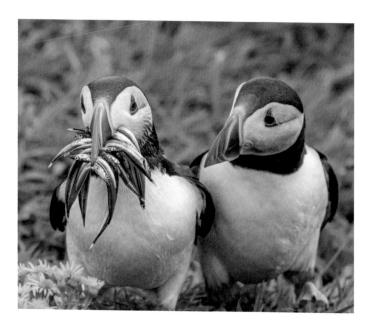

ANIMALS: Atlantic Puffin

LOCATION: SCOTLAND

Nope, there's plenty more fish in the sea, mate.

PHOTOGRAPHER: Krisztina Scheeff

ANIMAL: Spermophile

LOCATION: HUNGARY

"I dreamed a dream in time gone by."

PHOTOGRAPHER: Roland Kranitz

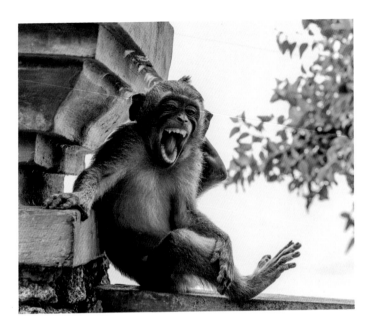

ANIMAL: Macaque
LOCATION: ULUWATU TEMPLE, BALI
You said act natural, right? Well, here it is!
PHOTOGRAPHER: Luis Marti

ANIMALS: Elephant and calf
LOCATION: KAZIRANGA, INDIA
"Mummy, look what I found!"
PHOTOGRAPHER: Kunal Gupta

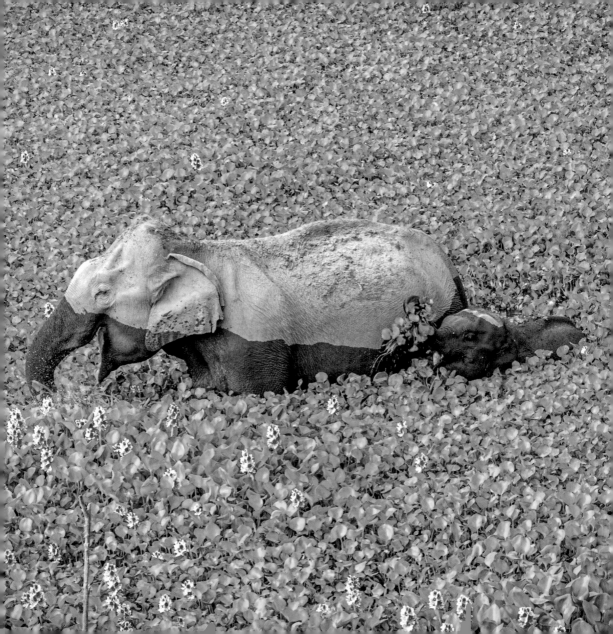

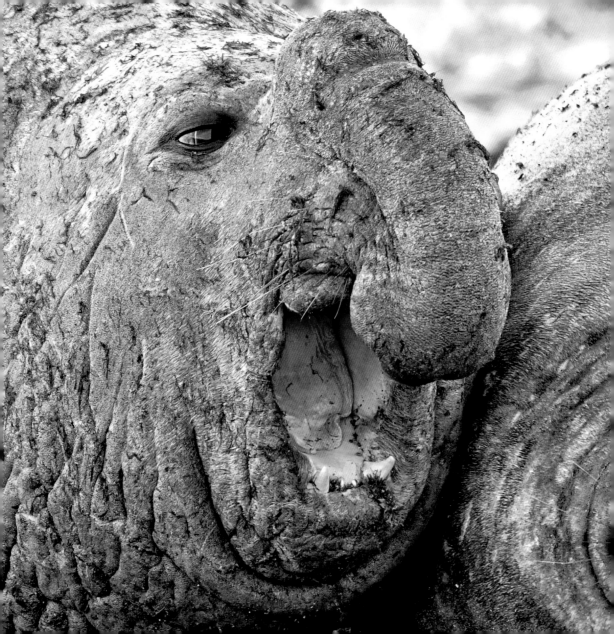

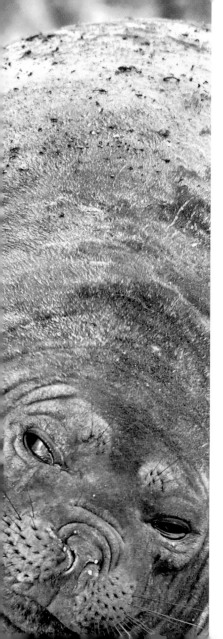

ANIMALS: South Sea Elephant (Mirounga)
LOCATION: ISLA ESCONDIDA, CHUBUT, PATAGONIA,
ARGENTINA
I just had the one drink, honest, can I come to bed? *side eye*
PHOTOGRAPHER: Luis Burgueno

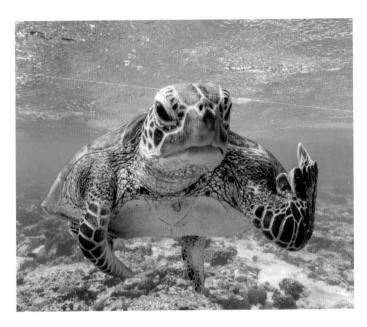

ANIMAL: Sea Turtle
LOCATION: LADY ELLIOT ISLAND, GREAT BARRIER REEF, AUSTRALIA
You lot with the camera – get lost! I've put up with Attenborough and his lot for weeks already!
PHOTOGRAPHER: Mark Fitzpatrick

ANIMAL: Mountain Gorilla
LOCATION: MGAHINGA GORILLA NATIONAL PARK, UGANDA
You look how I feel!
PHOTOGRAPHER: Marcus Westberg

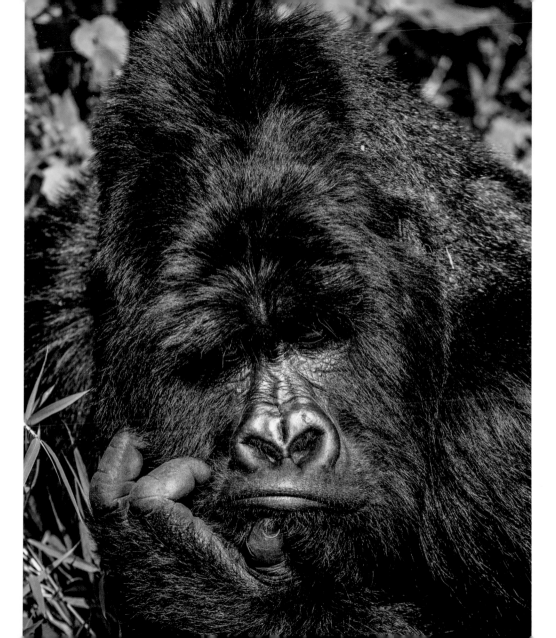

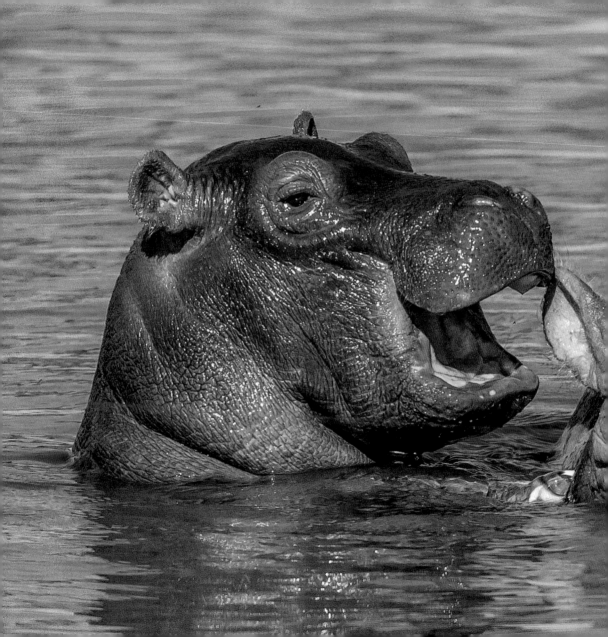

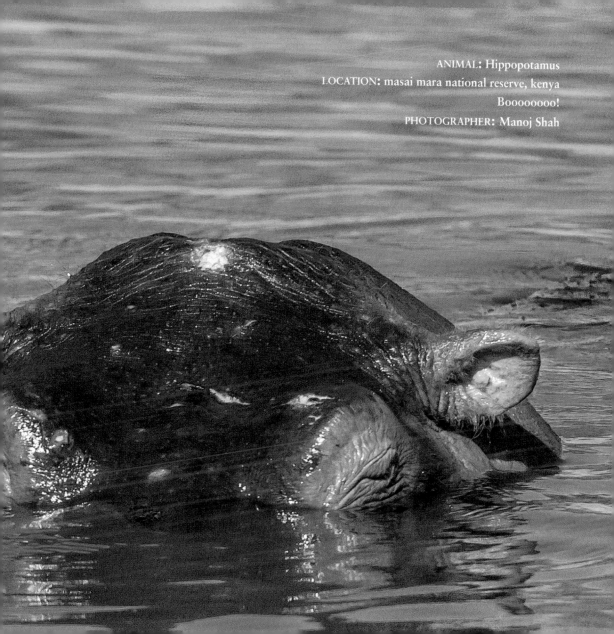

ANIMAL: Hippopotamus
LOCATION: masai mara national reserve, kenya
Boooooooo!
PHOTOGRAPHER: Manoj Shah

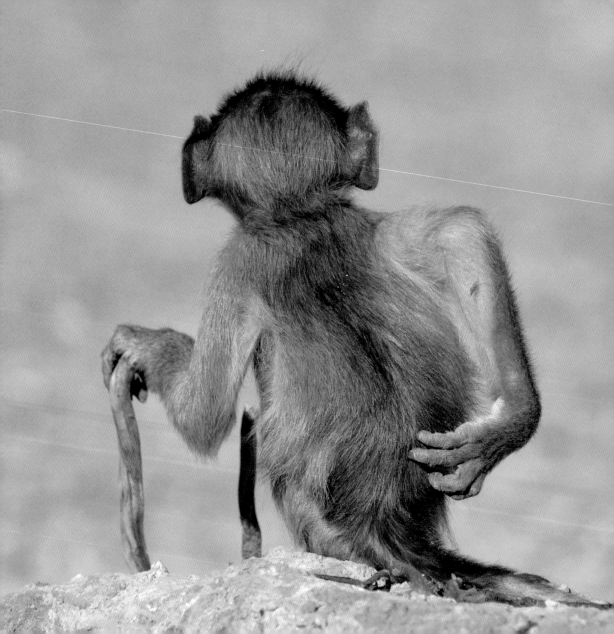

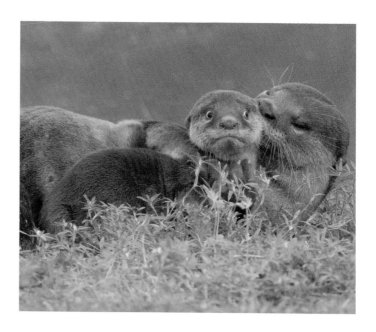

ANIMALS: Smooth-coated Otter
LOCATION: SINGAPORE
Mum, do you have to do the *spit on your arm and wipe my face thing* in front of the school gates?!
PHOTOGRAPHER: Max Teo

ANIMAL: Chacma Baboon
LOCATION: RIVER CHOBE, BOTSWANA
I mean, we all get up to it when we think no one's looking...
PHOTOGRAPHER: Martin Grace

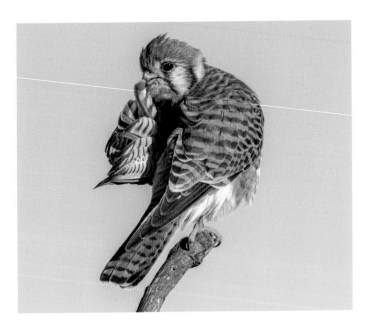

ANIMAL: Kestrel
LOCATION: HUNTINGTON BEACH, CALIFORNIA, USA
I've warned you once, mate – the sound of your shutter is scaring
off my dinner! A guy's gotta eat here.
PHOTOGRAPHER: Mike Lessel

ANIMALS: Southern Pig-tailed Macaque
LOCATION: KINABATANGAN RIVER IN BORNEO, MALAYSIA
I'll tell you one thing: Attenborough doesn't show you this sort of
monkey business on his documentaries.
PHOTOGRAPHER: Megan Lorenz

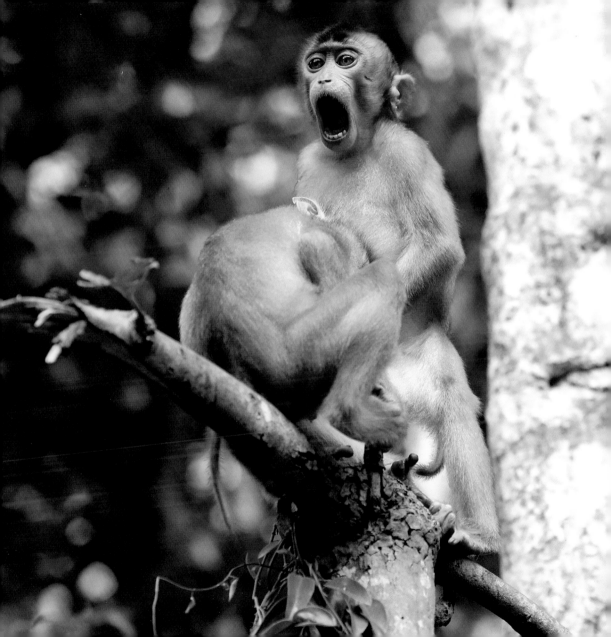

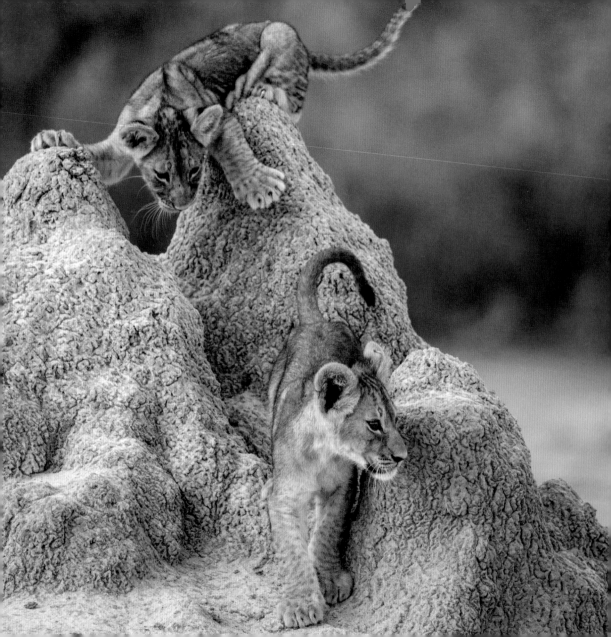

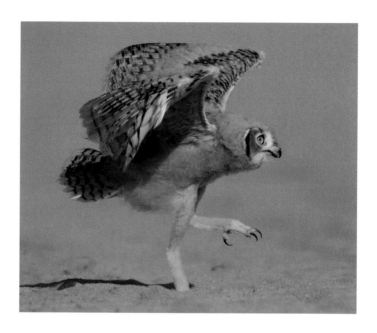

ANIMAL: Eagle Owl Chick
LOCATION: SAKAKA AL-JOUF, SAUDI ARABIA
Someone's been inspired by Mr Miyagi from *The Karate Kid*....
PHOTOGRAPHER: Nader Al-Shammari

ANIMALS: African Lion Cubs
LOCATION: HWANGE NATIONAL PARK, ZIMBABWE
I've got you in my sights – it's payback time!
PHOTOGRAPHER: Olin Rogers

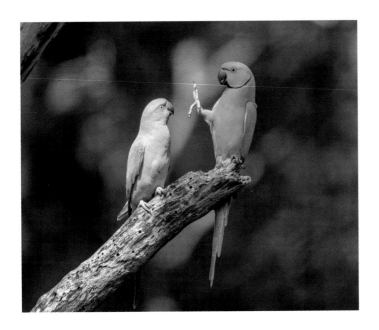

ANIMAL: Rose-ringed Parakeet

LOCATION: KAUDULLA NATIONAL PARK, SRI LANKA

You talk to the talon, girlfriend!

PHOTOGRAPHER: Petr Sochman

ANIMALS: African Penguin

LOCATION: BOULDER'S BEACH, CAPE TOWN, SOUTH AFRICA

Nothing to see here, people.

PHOTOGRAPHER: Pearl Kasparian

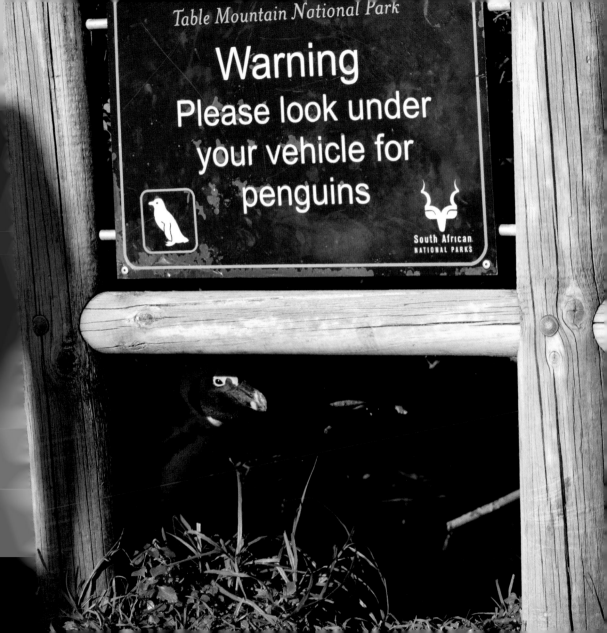

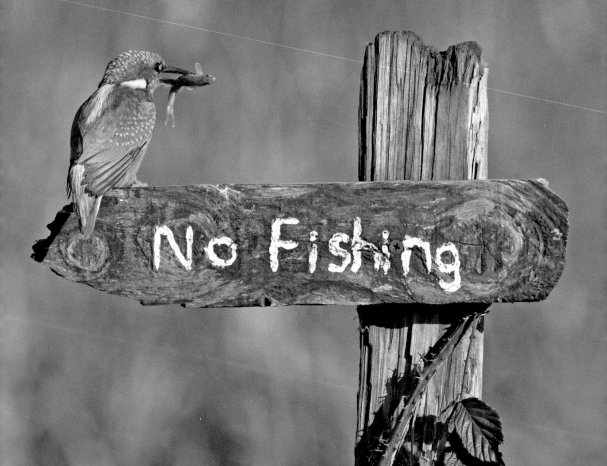

ANIMAL: Japanese Macaque
LOCATION: JIGOKUDANI MONKEY
PARK, JAPAN
This Japanese Macaque has been
watching way too much *Rocky*.
PHOTOGRAPHER: Ramesh Letchmanan

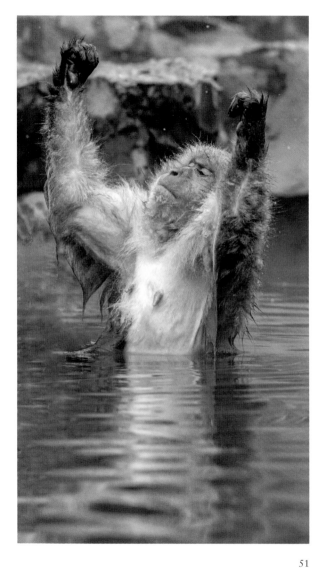

ANIMAL: Kingfisher
LOCATION: KIRKCUDBRIGHT
"Smash the system" said the
revolutionary Kingfisher.
PHOTOGRAPHER: Sally-Lloyd Jones

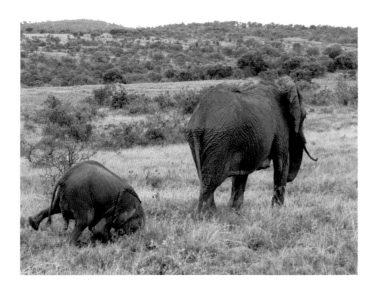

ANIMALS: African Elephant
LOCATION: NAMIBIA
The animals went in two by two, hurraarrrghhhhhhhh.
PHOTOGRAPHER: Tim Hearn

ANIMALS: Langur
LOCATION: KABINI, INDIA
Tails, you lose!
PHOTOGRAPHER: Thomas Vijayan

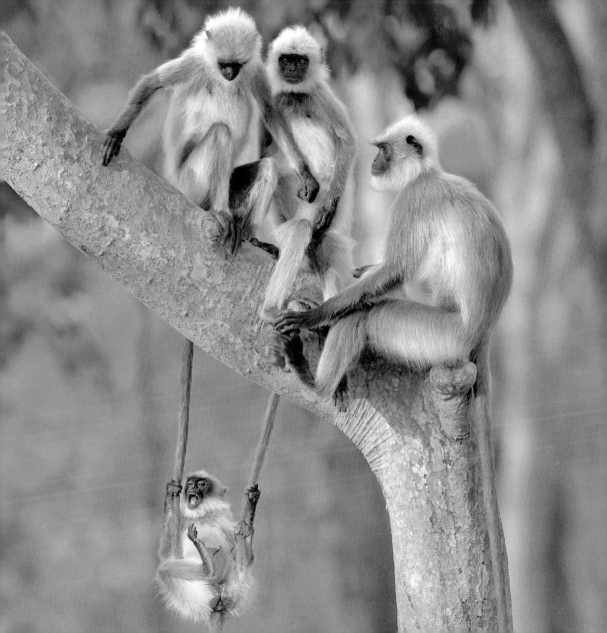

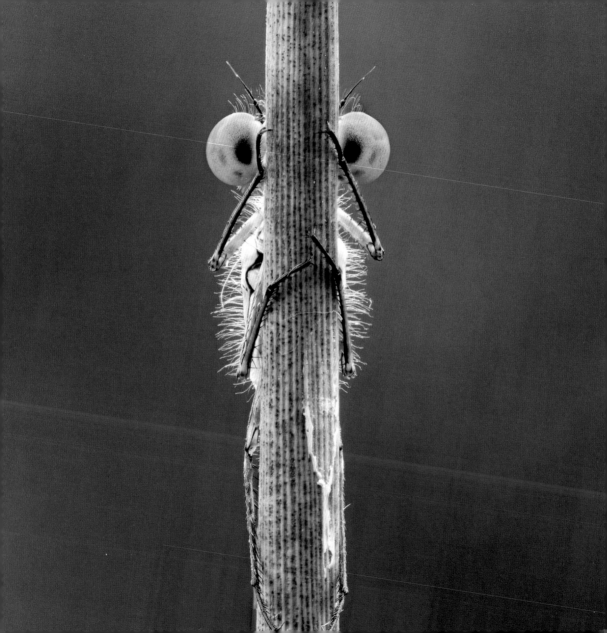

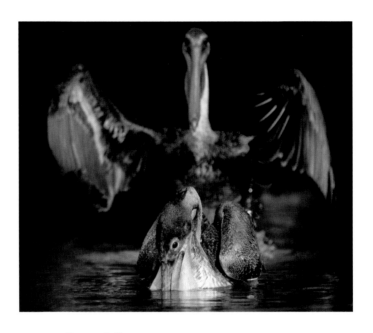

ANIMAL: Brown Pelican

LOCATION: FORT MYERS BEACH, FLORIDA

Quick, out the way, there's a pelican crossing!

PHOTOGRAPHER: Vicki Jauron

ANIMAL: Azure Damselfly

LOCATION: DEVON, UK

Well this is a safer place to hide than the net of that table tennis table
where I kept on being picked up and served with...

PHOTOGRAPHER: Tim Hearn

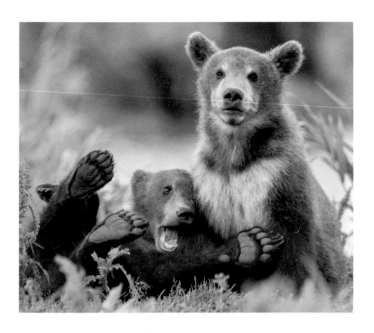

ANIMALS: Brown Bear Cubs
LOCATION: KURIL LAKE, KAMCHATKA, RUSSIA
We all have that one friend who refuses to let you take a serious photo for your LinkedIn profile.
PHOTOGRAPHER: Yarin Klein

ANIMALS: Monkey
LOCATION: JAPAN
It's always the same, isn't it? Dive in and get it over with or inch in and wince until you pluck up the courage to dunk your head under.
PHOTOGRAPHER: Wei Ping Peng

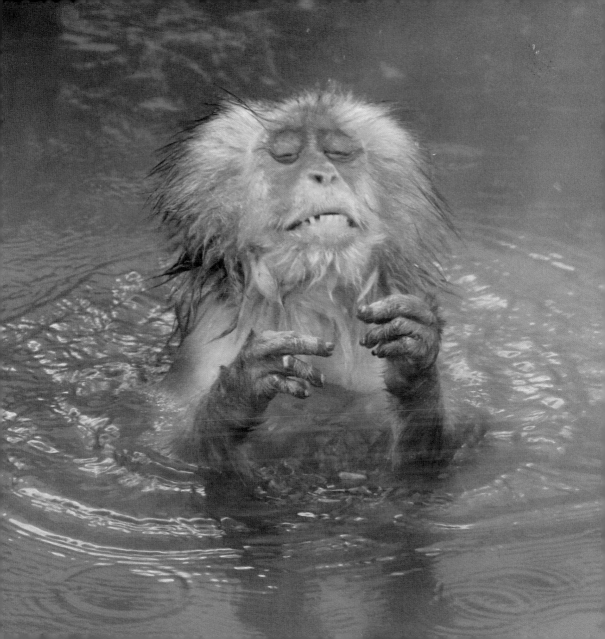

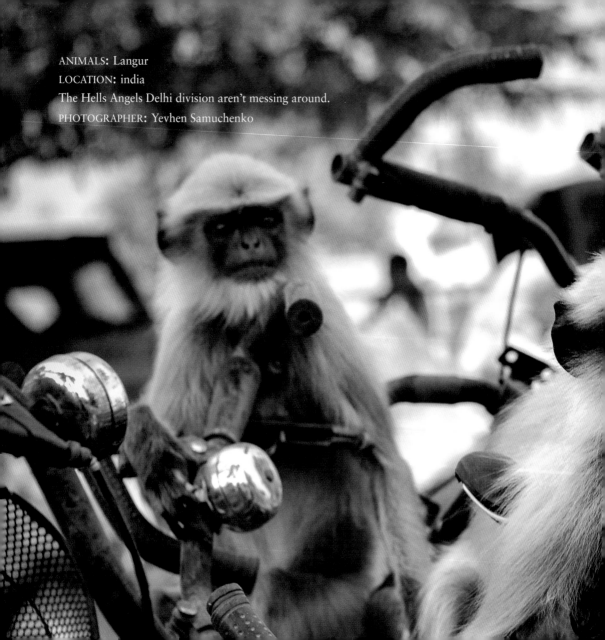

ANIMALS: Langur
LOCATION: india
The Hells Angels Delhi division aren't messing around.
PHOTOGRAPHER: Yevhen Samuchenko

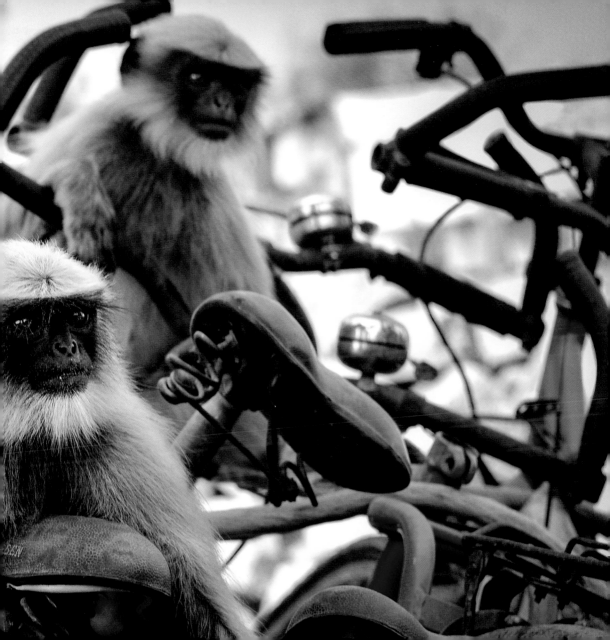

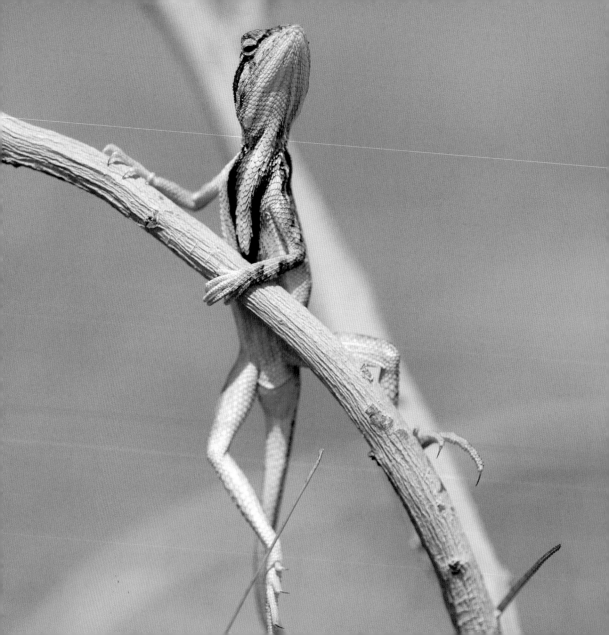

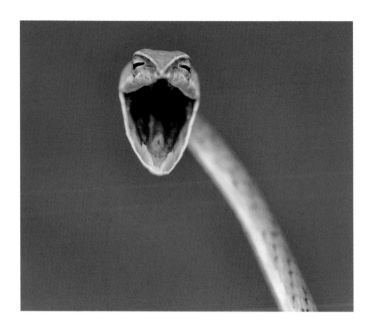

ANIMAL: Vine Snake

LOCATION: INDIA

"Fangs very much" – gets me every time.

PHOTOGRAPHER: Aditya Kshirsagar

ANIMAL: Fan-throated Lizard

LOCATION: INDIA

Lizards do pull-ups with style, don't they?

PHOTOGRAPHER: Aditya Kshirsagar

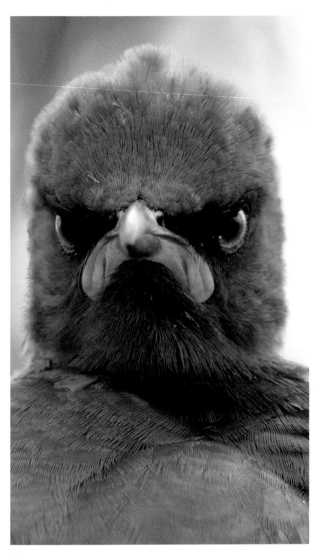

ANIMAL: Pied Starling
LOCATION: RIETVLEI NATURE
RESERVE, SOUTH AFRICA
The original angry bird.
PHOTOGRAPHER: Andrew Mayes

ANIMALS: Smooth-coated Otter
LOCATION: SINGAPORE
It's funny how all playgrounds look
the same when it's time to go home.
PHOTOGRAPHER: Chee-Kee-Teo

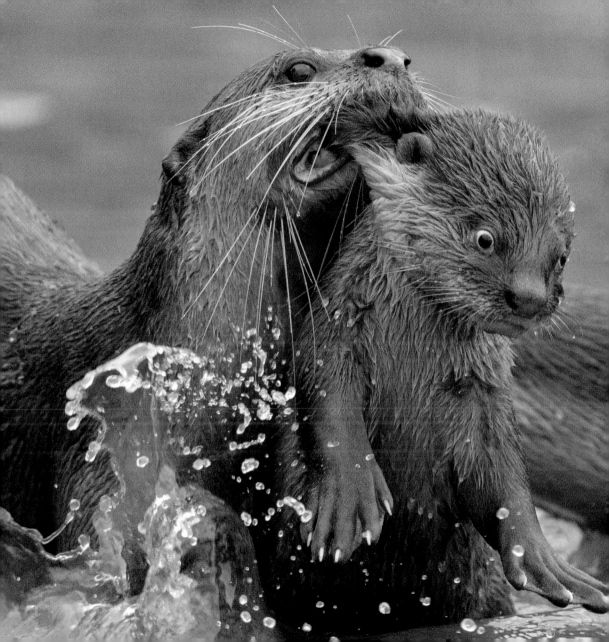

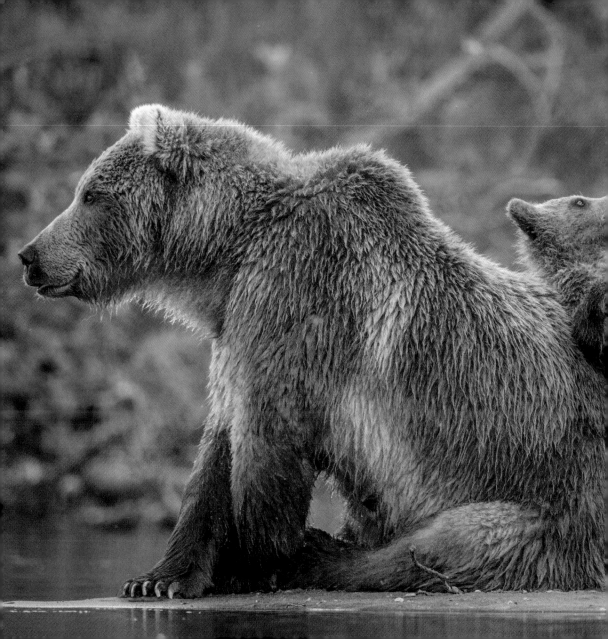

ANIMALS: Kamchatka Brown Bear
LOCATION: KAMCHATKA PENINSULA, RUSSIA
So Mum can now add "scratching post" to her ever-lengthening list of child-rearing duties.
PHOTOGRAPHER: Andy Parkinson

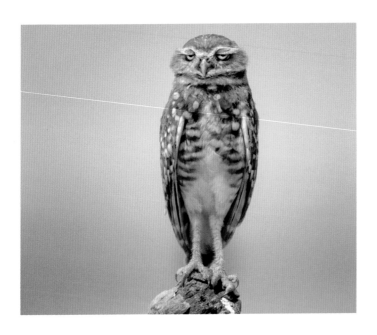

ANIMALS: Burrowing Owl
LOCATION: SAN BERNARDINO COUNTY, CALIFORNIA, USA
So that's why you don't usually see owls in the daytime – they've
all got hangovers.
PHOTOGRAPHER: Anita Ross

ANIMALS: Bald Eagle and Prairie Dog
LOCATION: LONGMONT, USA
The introduction of air traffic controllers really has changed things
on the prairies recently.
PHOTOGRAPHER: Arthur Trevino

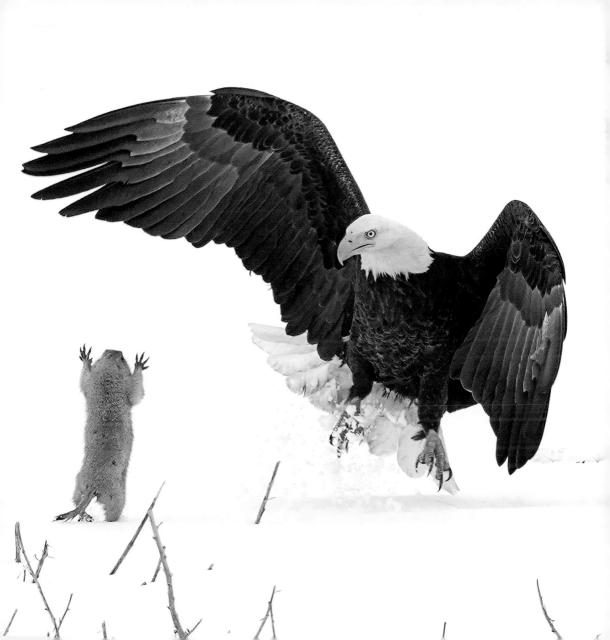

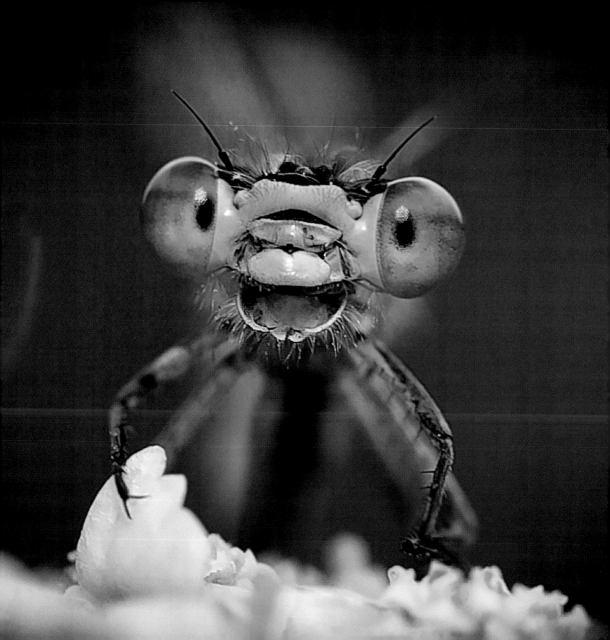

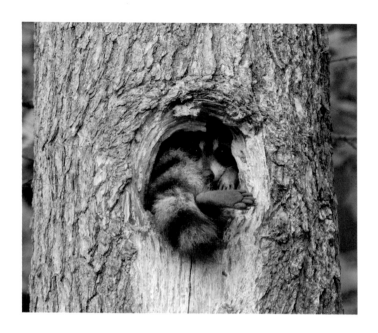

ANIMAL: Racoon

LOCATION: WISCONSIN RAPIDS, USA

Now I understand what the estate agent meant when he called this place "bijou".

PHOTOGRAPHER: Brook Burling

ANIMAL: Dragonfly

LOCATION: HEMER, GERMANY

"Don't worry, be happy," said the summer-loving dragonfly dude.

PHOTOGRAPHER: Axel Bocker

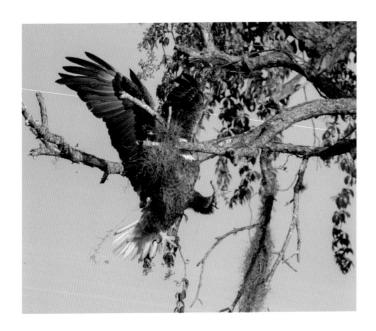

ANIMAL: Bald Eagle
LOCATION: SOUTH WEST FLORIDA, USA
The recently released outtake for the design for the
US President's seal.
PHOTOGRAPHER: David Eppley

ANIMAL: Gosling
LOCATION: LEE VALLEY PARK, LONDON, UK
Orville sets the standard during the limbo event at the
Duck Olympics.
PHOTOGRAPHER: Charlie Page

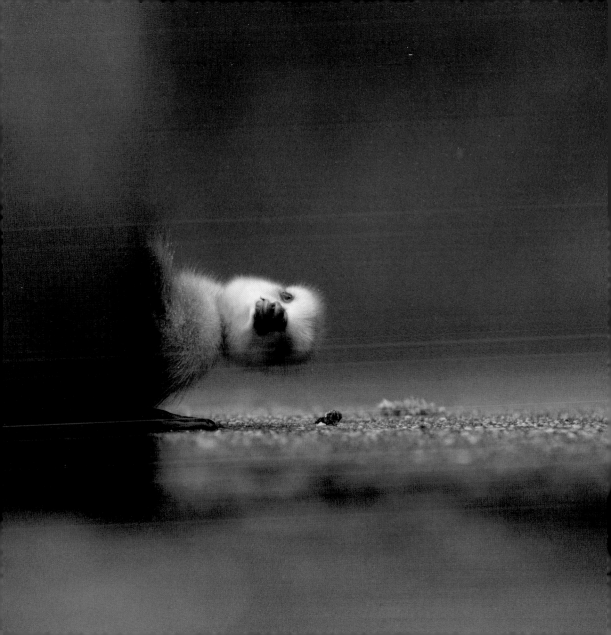

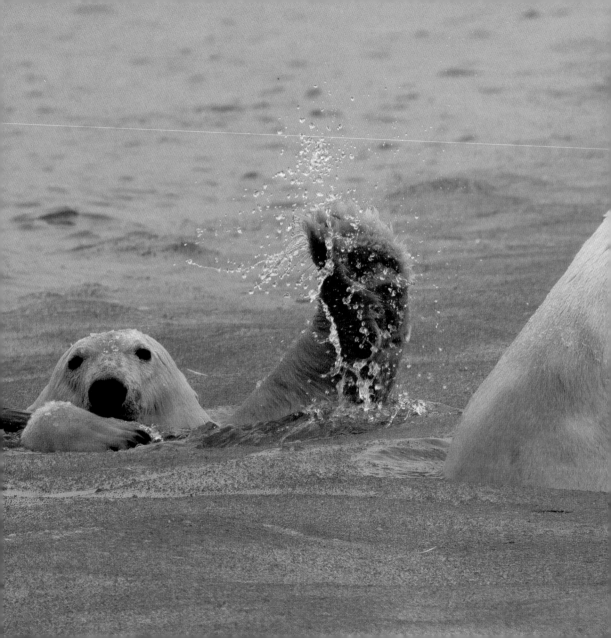

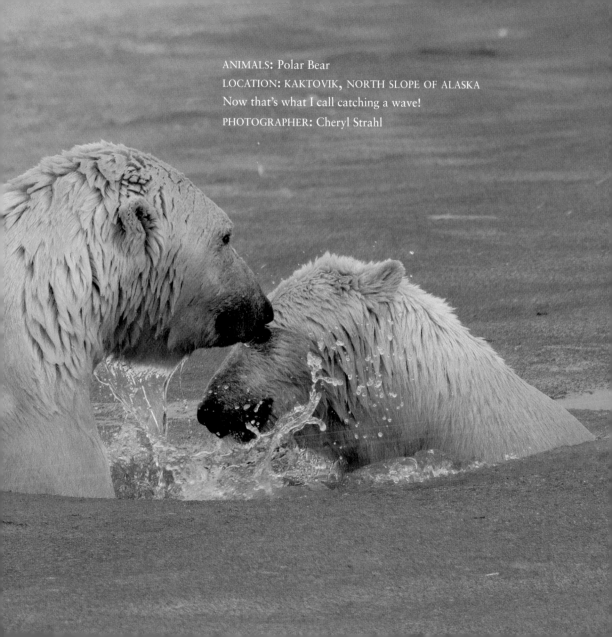

ANIMALS: Polar Bear
LOCATION: KAKTOVIK, NORTH SLOPE OF ALASKA
Now that's what I call catching a wave!
PHOTOGRAPHER: Cheryl Strahl

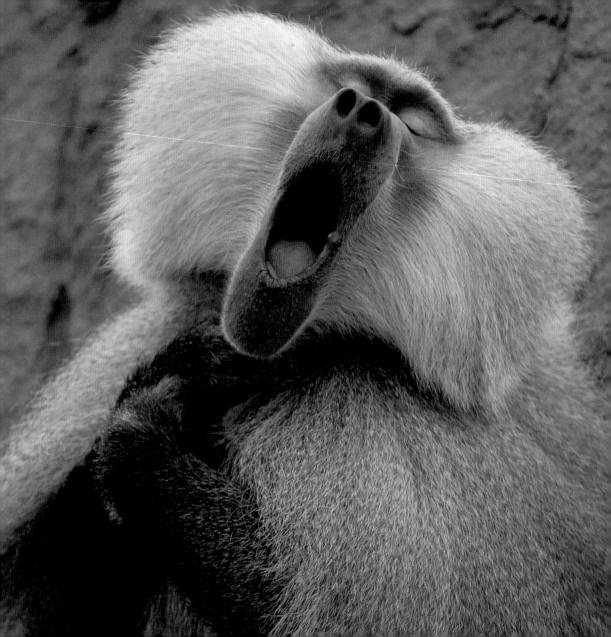

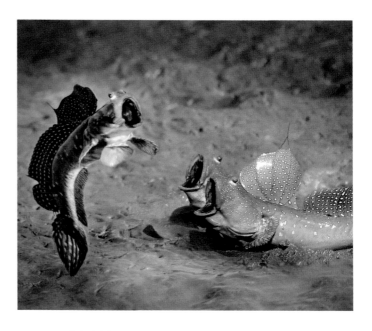

ANIMALS: Mudskipper
LOCATION: TAIPEI, TAIWAN
The mudskipper's arabesque left the judges open-mouthed.
PHOTOGRAPHER: Chu han lin

ANIMAL: Baboon
LOCATION: SAUDI ARABIA
"O Sole Mio" belted out the baritone baboon.
PHOTOGRAPHER: Clemence Guinard

ANIMALS: Monkey and Giraffe
LOCATION: MURCHISON FALLS NP, UGANDA
Now that's a steed befitting the king of the swingers.
PHOTOGRAPHER: Dirk Jan Steehouwer

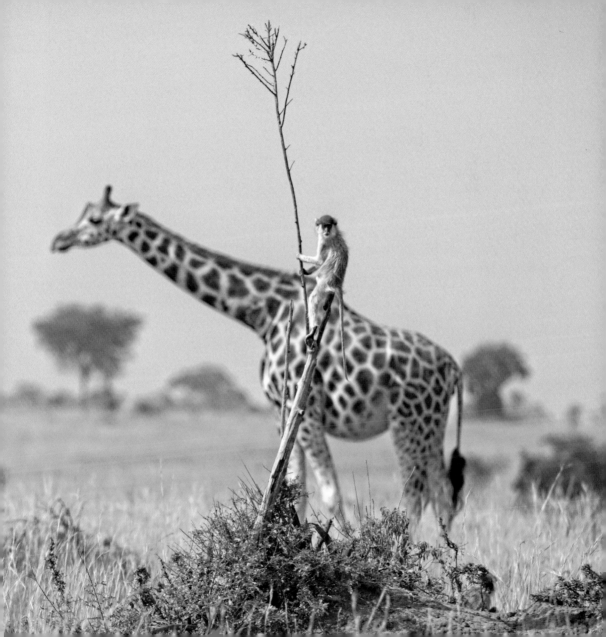

ANIMALS: Racoon
LOCATION: KASSEL, GERMANY
"Great news, friend! The bin men have gone on strike again."
PHOTOGRAPHER: Jan Piecha

ANIMAL: Proboscis Monkey
LOCATION: BORNEO
The literal origin of "face plant".
PHOTOGRAPHER: Jakub Hodan

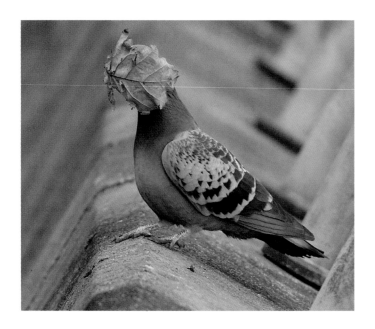

ANIMAL: Pigeon
LOCATION: OBAN, ARGYLL, SCOTLAND
The old "If I can't see them, they can't see me" trick still works a charm.
PHOTOGRAPHER: John Speirs

ANIMAL: Golden Silk Monkey
LOCATION: YUNNAN, CHINA
So that's why everyone else was crossing the rope bridge with the rope above their heads...
PHOTOGRAPHER: Ken Jensen

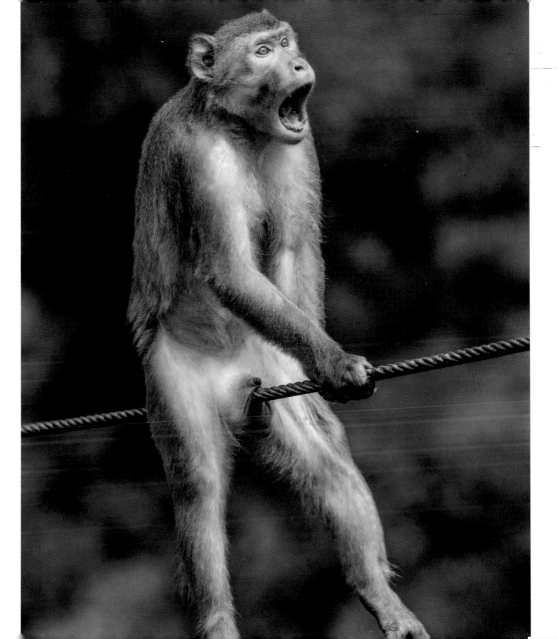

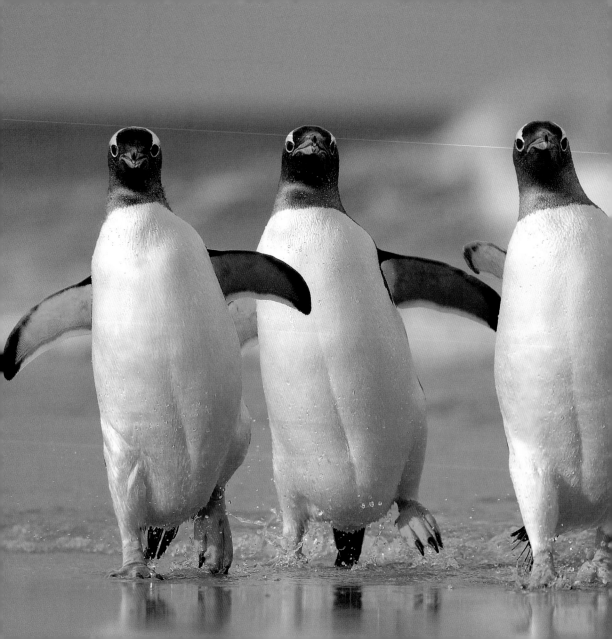

ANIMALS: Gentoo Penguins

LOCATION: EAST FALKLAND, FALKLAND ISLANDS

You put your left leg in, and you shake it all about!

PHOTOGRAPHER: Joshua Galicki

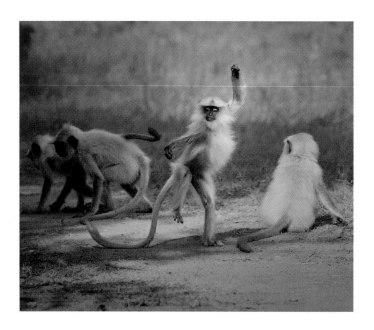

ANIMALS: Langur

LOCATION: TADOBA ANDHARI TIGER RESERVE, INDIA

Sometimes the rhythm is going to get you!

PHOTOGRAPHER: Sarosh Lodhi

ANIMAL: Spermophile

LOCATION: HUNGARY

Strictly Come Dancing has proved to be a hit everywhere, it seems!

PHOTOGRAPHER: Roland Kranitz

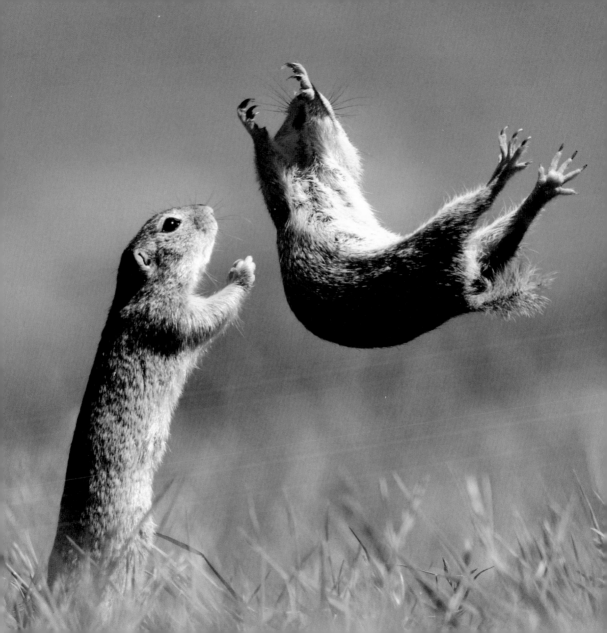

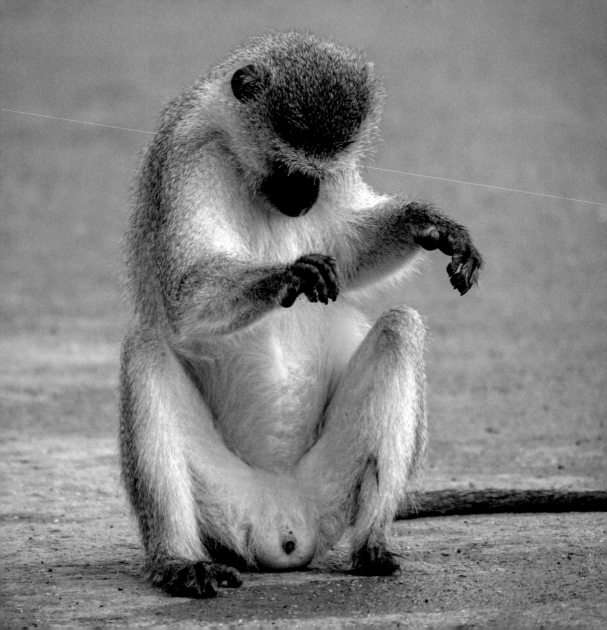

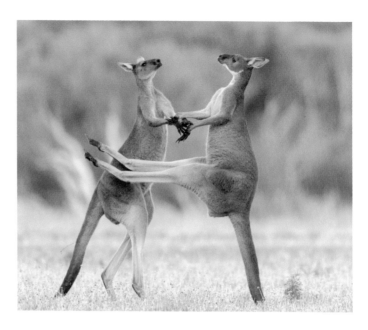

ANIMALS: Western Grey Kangaroo

LOCATION: PERTH, WESTERN AUSTRALIA

I thought you were going to catch me!

PHOTOGRAPHER: Lea Scaddan

ANIMAL: Vervet Monkey

LOCATION: SOUTH LUANGWA NATIONAL PARK, ZAMBIA

Has that always been blue?!

PHOTOGRAPHER: Larry Petterborg

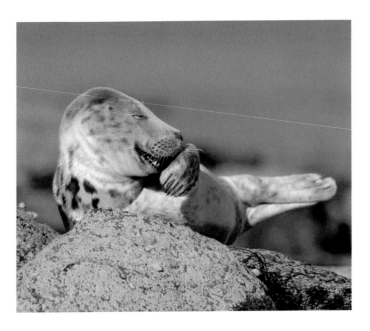

ANIMAL: Grey Seal

LOCATION: RAVENSCAR, UK

"Haha, my lips are sealed...' Love it.

PHOTOGRAPHER: Martina Novotna

ANIMAL: Kangaroo

LOCATION: PERTH, AUSTRALIA

"My heart will go on and on...'

PHOTOGRAPHER: Lea Scaddan

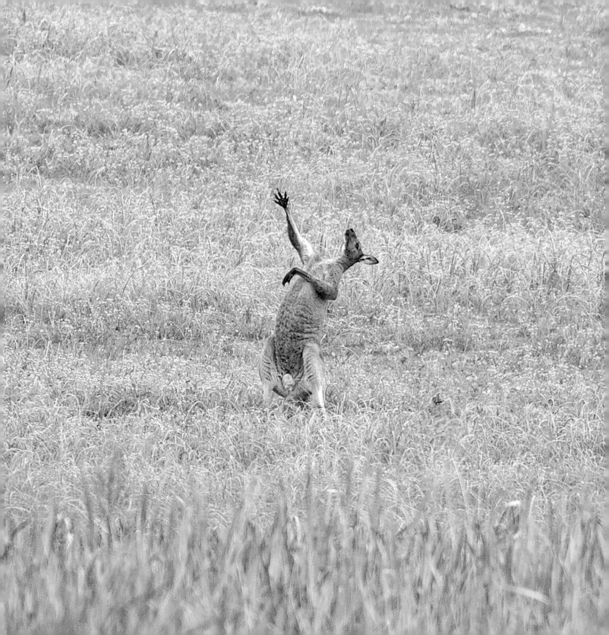

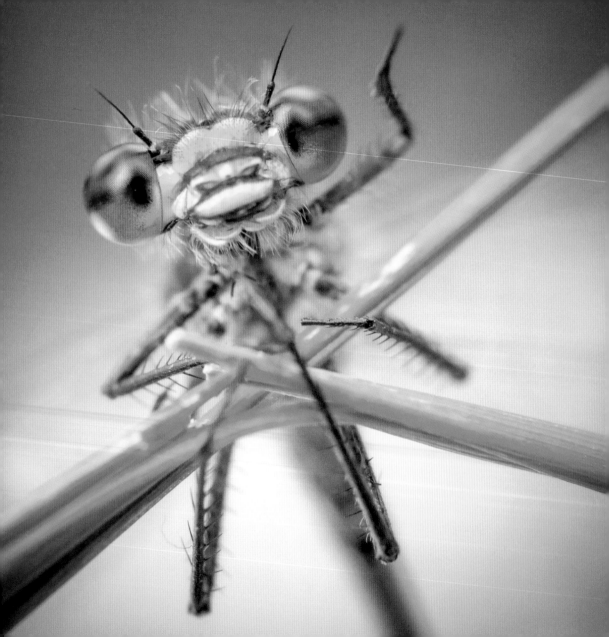

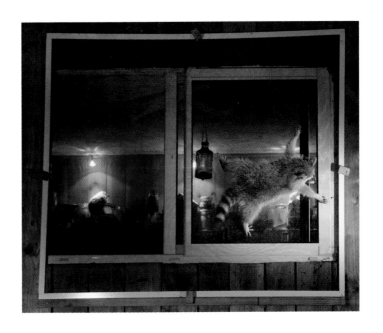

ANIMAL: Racoon
LOCATION: FRANCE
Next time I really must try the doorbell.
PHOTOGRAPHER: Nicolas de Vaulx

ANIMAL: Red Damselfly
LOCATION: GOTHENBURG, SWEDEN
Sure you can take my picture, but just make sure you turn off the
anti-red-eye feature in Photoshop!
PHOTOGRAPHER: Mattias Hammar

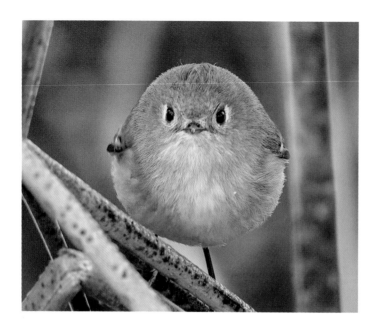

ANIMAL: Ruby-crowned Kinglet
LOCATION: ATASCADERO, CALIFORNIA, USA
Did I say you could take my picture?
PHOTOGRAPHER: Patrick Dirlam

ANIMAL: Brown Bear
LOCATION: HARGITA MOUNTAINS, ROMANIA
The bears were making every effort to stop Goldilocks nicking their porridge again.
PHOTOGRAPHER: Pal Marchhart

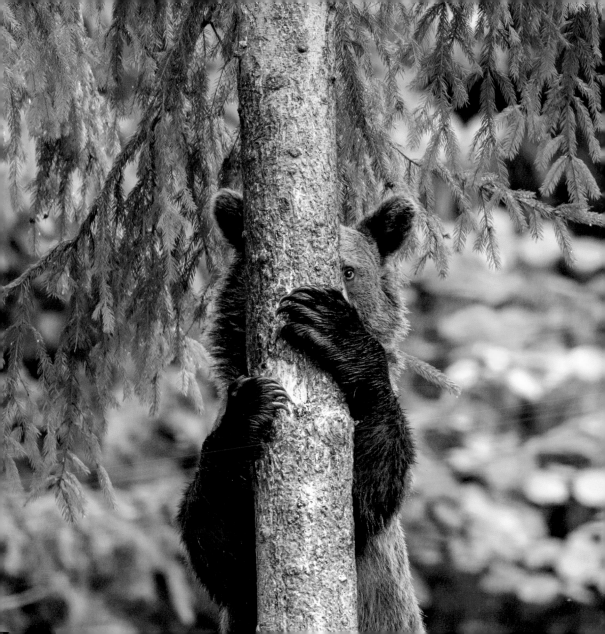

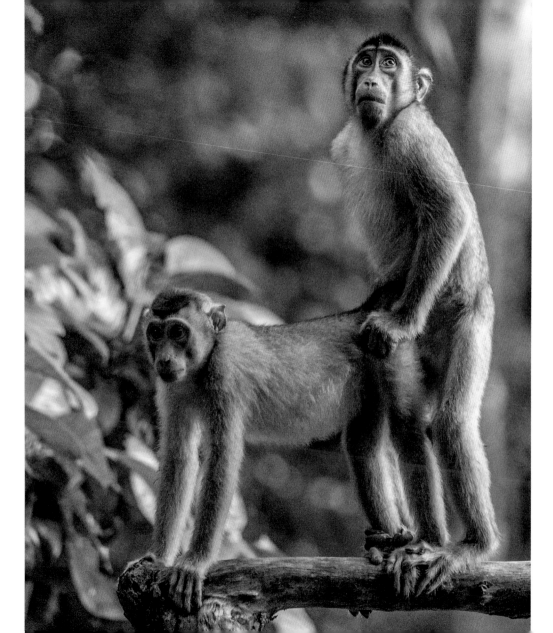

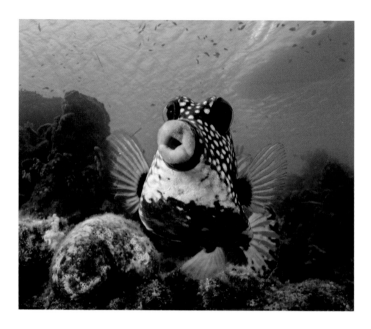

ANIMAL: Boxfish

LOCATION: CURAÇO, DUTCH CARIBBEAN

Do you think this is a bit forward for my Tinder profile picture?

PHOTOGRAPHER: Philipp Stahr

ANIMALS: Pig-tailed Macaque

LOCATION: BORNEO

Oooh, that looks bad. Er, we were playing leapfrog and suddenly
I got startled. That'll work as an excuse, right?

PHOTOGRAPHER: Peter Haygarth

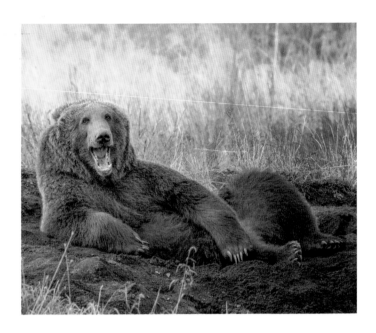

ANIMAL: Kodiak Brown Bear
LOCATION: KODIAK, ALASKA
Draw me like one of your French bears!
PHOTOGRAPHER: Wenona Suydam

ANIMAL: Asian Tiger
LOCATION: JIM CORBETT NATIONAL PARK, INDIA
Tony the Tiger certainly was a surprise entrant in the tosssing the
caber event at this year's Highland Games.
PHOTOGRAPHER: Siddhant Agrawal

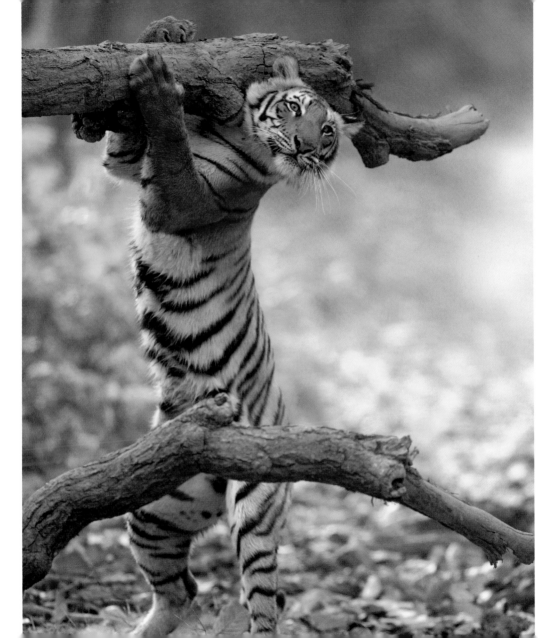

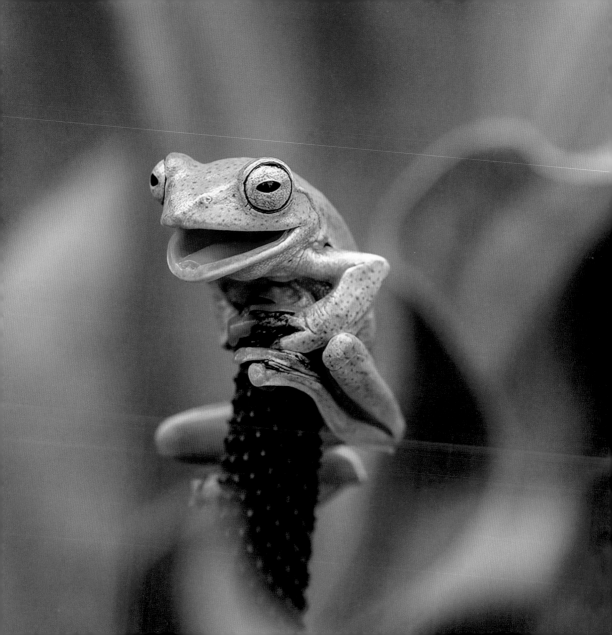

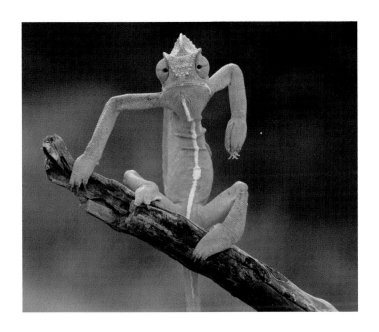

ANIMALS: Chameleon
LOCATION: WESTERN GHATS, INDIA
Chris the Chameleon tries to recreate David Brent's
legendary arm dance.
PHOTOGRAPHER: Gurumoorthy

ANIMAL: Green Tree Frog
LOCATION: TANGERANG, INDONESIA
Didn't really think through what I'd do once I reached the top...
PHOTOGRAPHER: Dikky Oesin

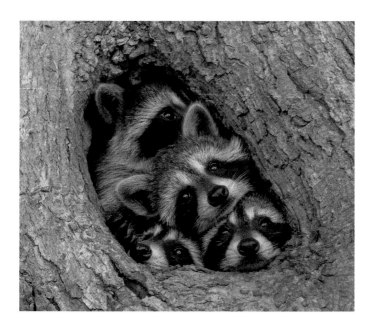

ANIMALS: Racoon
LOCATION: SOUTHEWESTERN ONTARIO, CANADA
Some folks take Covid quarantine more seriously than others.
PHOTOGRAPHER: Kevin Biskaborn

ANIMAL: Spermophile
LOCATION: HUNGARY
Squirrel soloist wins award for being outstanding in his field.
PHOTOGRAPHER: Roland Kranitz

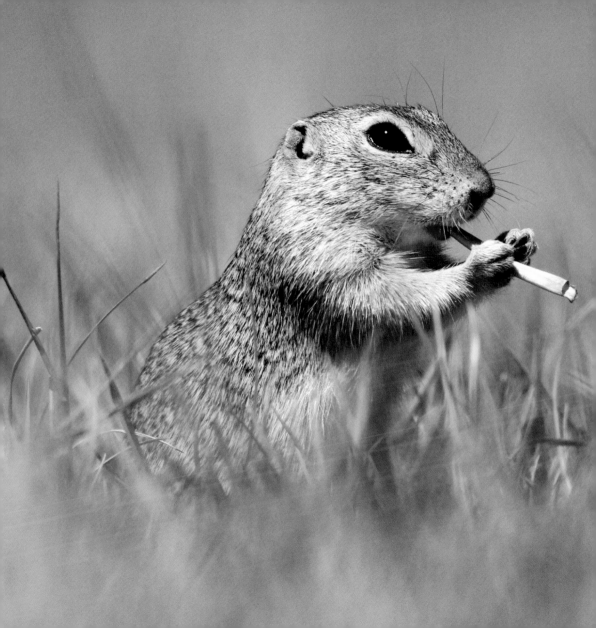

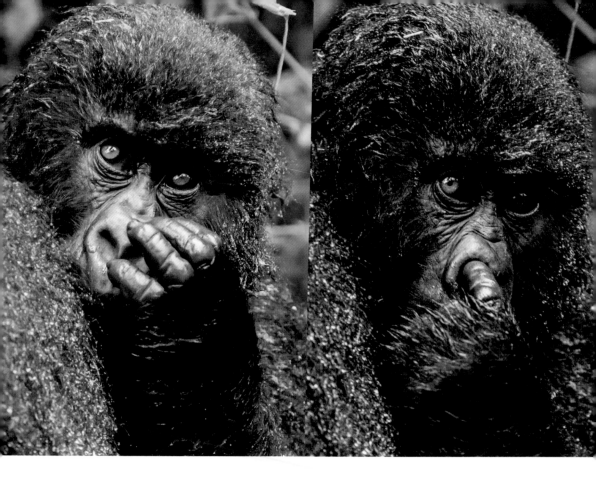

ANIMAL: Mountain Gorilla
LOCATION: VIRUNGA NATIONAL PARK, RWANDA
I mean, we've all done it at least once...
PHOTOGRAPHER: Cedric Favero

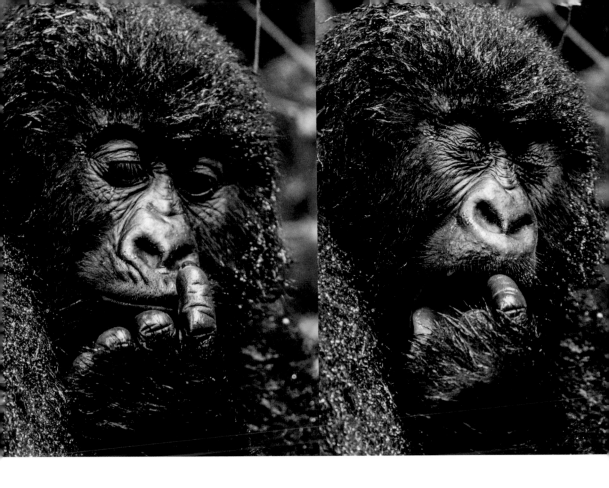

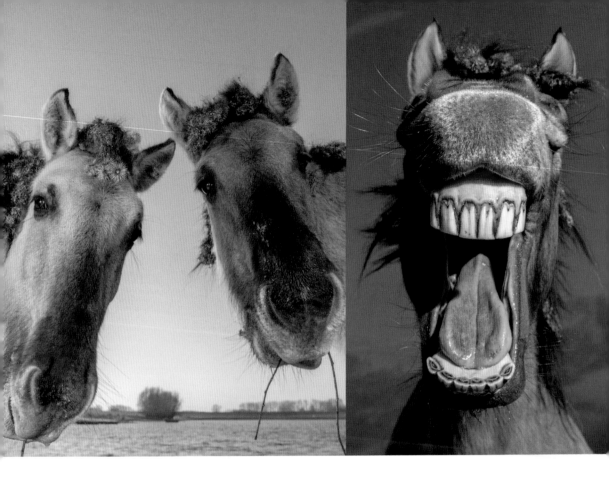

ANIMALS: Koniks

LOCATION: GROENLANDEN, OOIJ, NETHERLANDS

This is what happens when you leave disposable cameras on each table for the guests to use at weddings.

PHOTOGRAPHER: Edwin Smits

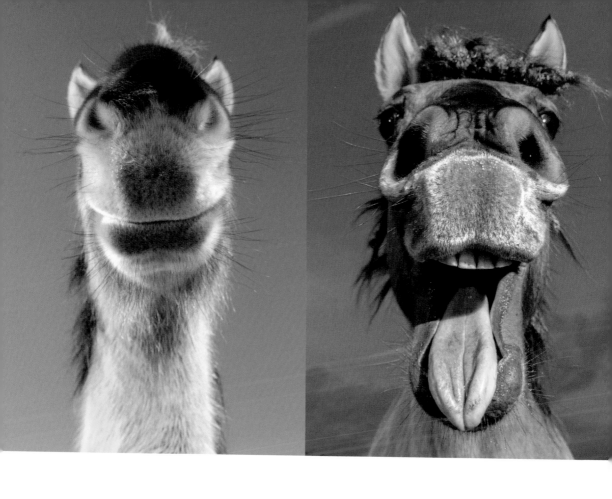

ANIMALS: King Penguins
LOCATION: SOUTH GEORGIA
Hey, you! Don't think you can
pretend no one's at home after
giving it all that!
PHOTOGRAPHER: Josef Friedhuber

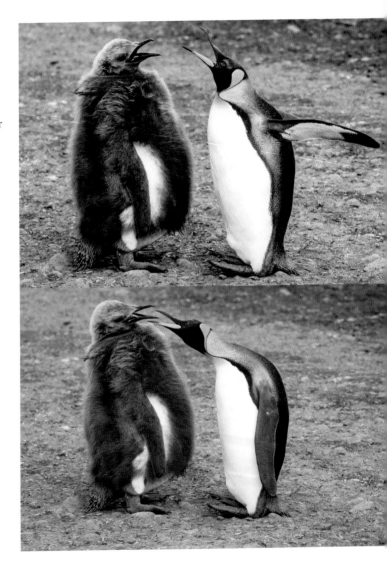

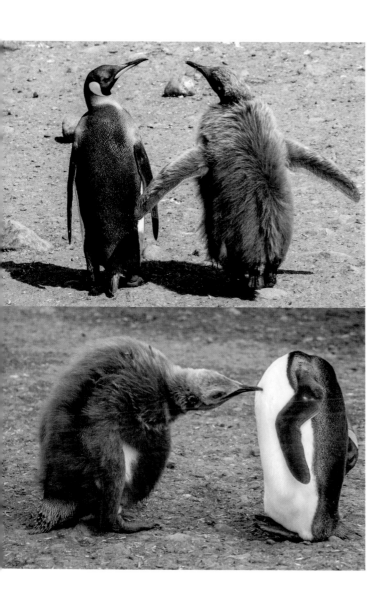

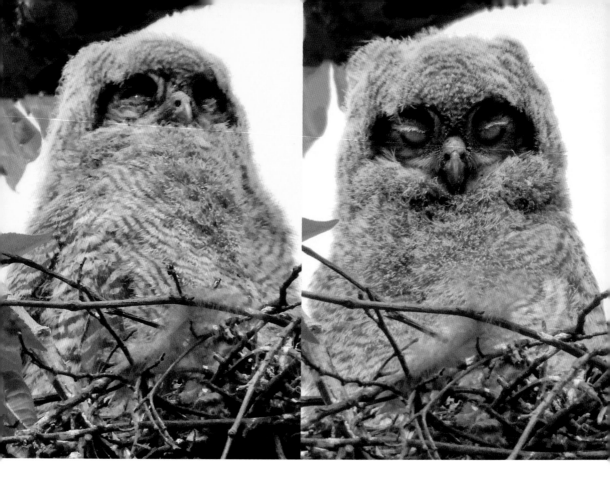

ANIMAL: Great Horned Owlet

LOCATION: LADNER, BC CANADA

The before and after the morning espresso sequence.

PHOTOGRAPHER: Natalie Tanrena

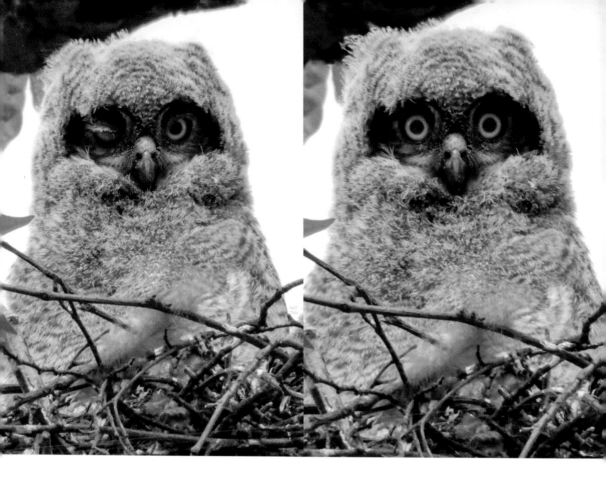

ANIMAL: African Elephant

LOCATION: MATUSADONA PARK, ZIMBABWE

If you're going for a mud bath, you've got to get stuck in, shake it off and scratch that little bit you didn't get!

PHOTOGRAPHER: Vicki Jauron

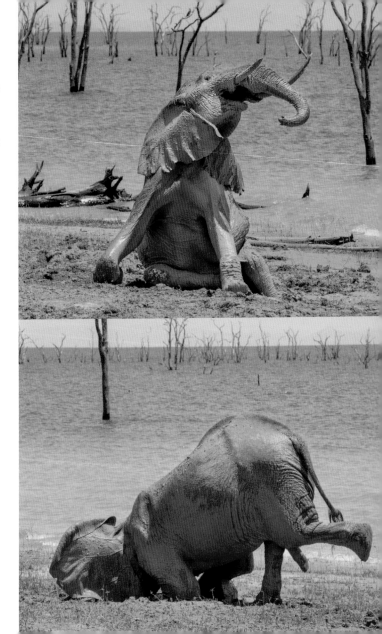

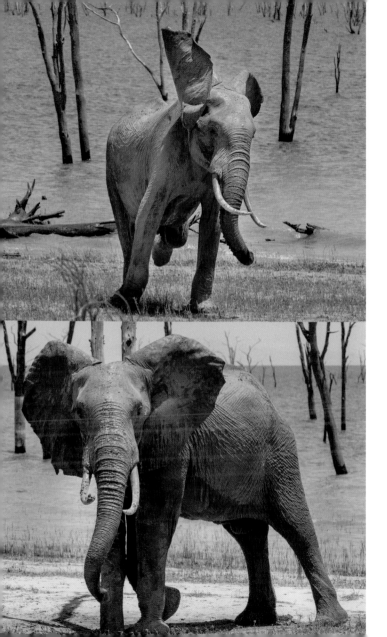

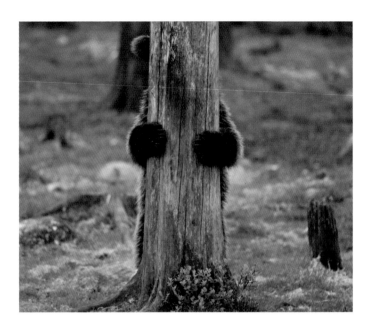

ANIMAL: Brown Bear
LOCATION: FINLAND
Ready or not, I'm coming to find you!
PHOTOGRAPHER: Valtteri Mulkahainen

ANIMAL: Mountain Gorilla
LOCATION: VIRUNGA MOUNTAINS, RWANDA, AFRICA
And tonight, Matthew, I'll be John Travolta from *Grease*.
PHOTOGRAPHER: Peter Haygarth

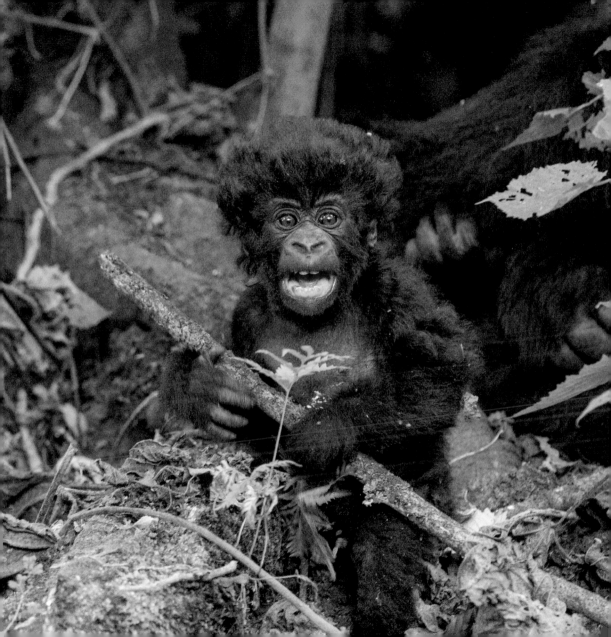

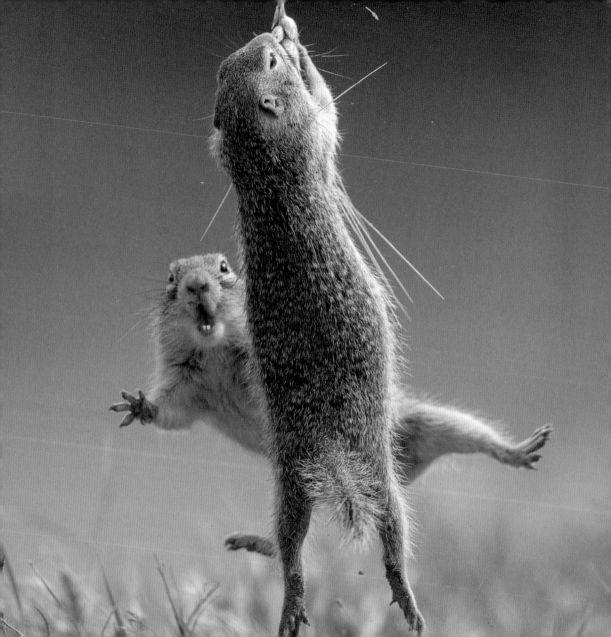

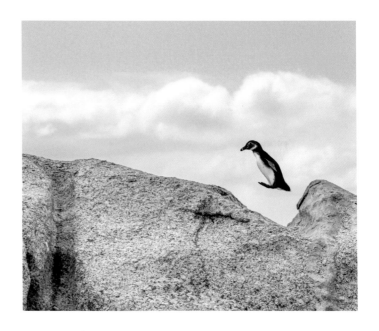

ANIMAL: African Penguin
LOCATION: BOULDERS BEACH, SOUTH AFRICA
Who says penguins can't fly?!
PHOTOGRAPHER: Anette Mossbacher

ANIMAL: Ground Squirrel
LOCATION: VIENNA, AUSTRA
'Fly, you fools!' bellowed Gandalf the Gopher.
PHOTOGRAPHER: Anne Lindner

ANIMALS: Polar Bear
LOCATION: SPITZBERG, NORWAY
From the makers of *The Owl and the Pussycat* comes...
PHOTOGRAPHER: Annick Lardeau

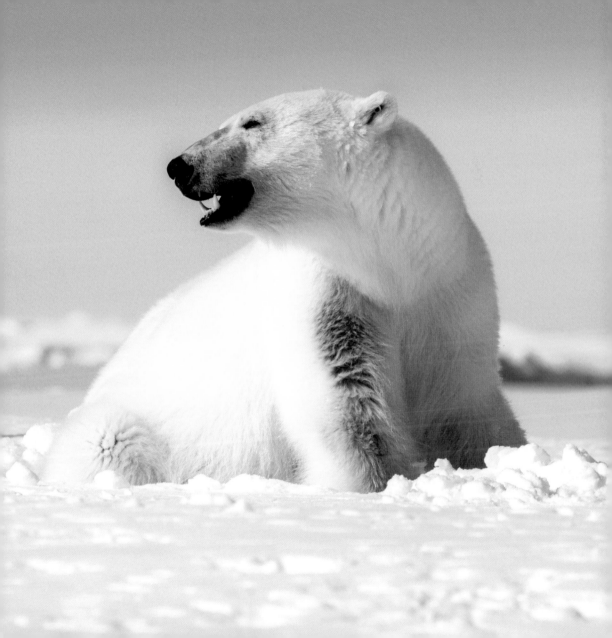

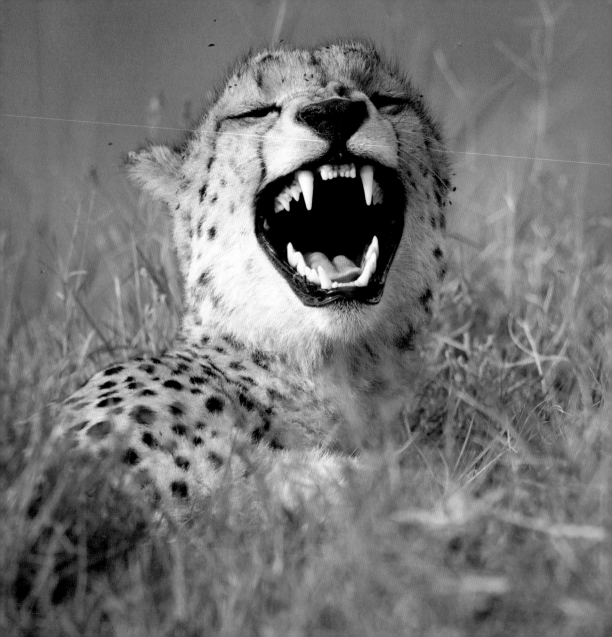

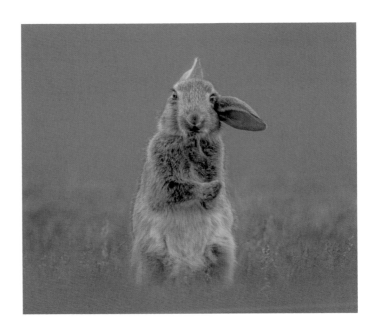

ANIMAL: Hare
LOCATION: RICHMOND PARK, LONDON, UK
I know kung fu!
PHOTOGRAPHER: Bart Vodderie

ANIMAL: Cheetah
LOCATION: PHINDA PRIVATE GAME RESERVE, SOUTH AFRICA
Not content with being the fastest creature on the planet, he could
also pull off a mean hyena impression.
PHOTOGRAPHER: Anthony Barry

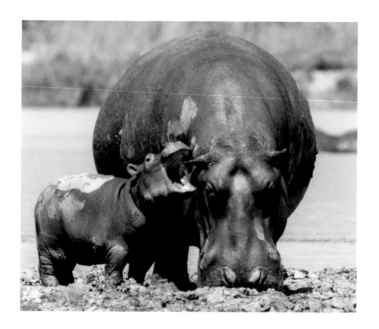

ANIMALS: Hippopotamuses
LOCATION: VWAZA GAME RESERVE, MALAWI
MUM! Stop ignoring me! Can I go back to the mud bath?
PHOTOGRAPHER: Rohin Bakshi

ANIMAL: Spermophile
LOCATION: NEUSIEDLERSEE, AUSTRIA
I asked for flowers, but I suppose you get what you're given...
PHOTOGRAPHER: Beatrice Verez

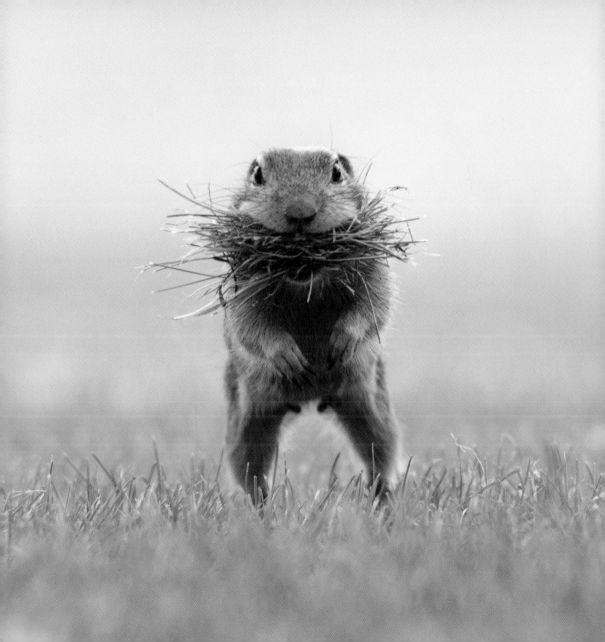

ANIMAL: Tawny Owl

LOCATION: LADNER BC CANADA

Another photographer falls for my camouflaged papier-mâché owl.
What a sucker!

PHOTOGRAPHER: Dan Hutchinson

ANIMAL: Juvenile Tricolored Heron

LOCATION: WAKODAHATCHEE WETLANDS, DELRAY BEACH,
FLORIDA, USA

Really regretting the decision to purchase the "firm hold" gel.

PHOTOGRAPHER: Bill Gozansky

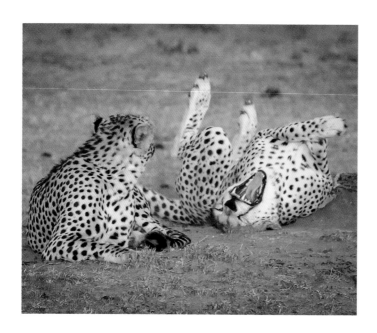

ANIMALS: Cheetahs

LOCATION: KENYA

And I said, "Sorry, mate, I'd love to join you, but I'm on a fast food diet."

PHOTOGRAPHER: Gerardo Flores

ANIMALS: Emperor Penguins

LOCATION: VOLUNTEER POINT, FALKLAND ISLANDS

Last one in's a rotten egg!

PHOTOGRAPHER: David Higgins

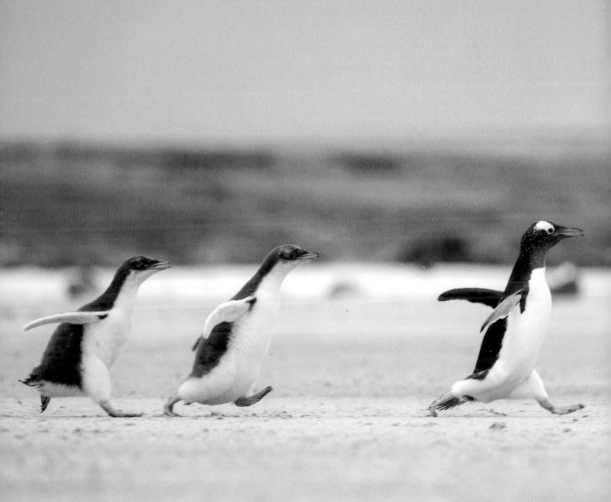

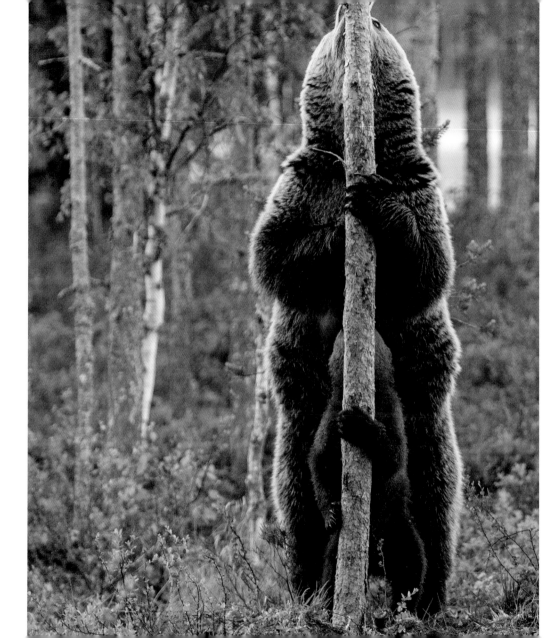

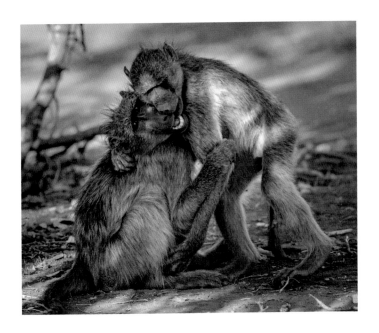

ANIMALS: Baboons

LOCATION: SOUTH GEORGIA

After social distancing rules came to an end, it seems everyone's forgotten how to hug each other properly.

PHOTOGRAPHER: Ilya Schiller

ANIMALS: Brown Bear

LOCATION: SUOMUSSALMI, FINLAND

And this, Son, is known in yoga as the Peeing Pose.

PHOTOGRAPHER: Ilkka Niskanen

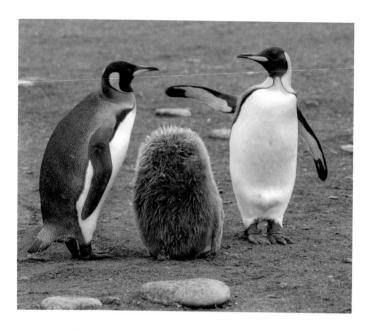

ANIMALS: Emperor penguins
LOCATION: SOUTH AFRICA
I leave you to babysit for one evening and I come back to find our son now has no head. What have you got to say for yourself?
PHOTOGRAPHER: Ilya Schiller

ANIMAL: Donkey
LOCATION: LITTLE RANN OF KUTCH, GUJARAT, INDIA
Wow, donkeys' backs really are super strong!
PHOTOGRAPHER: Jagdeep Rajput

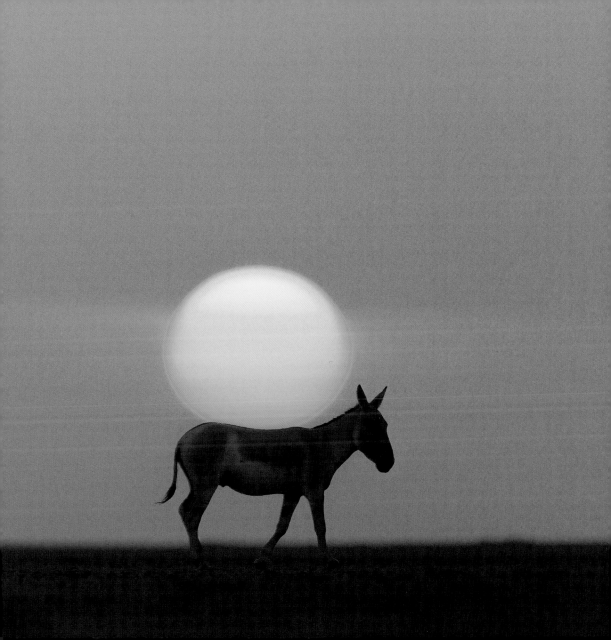

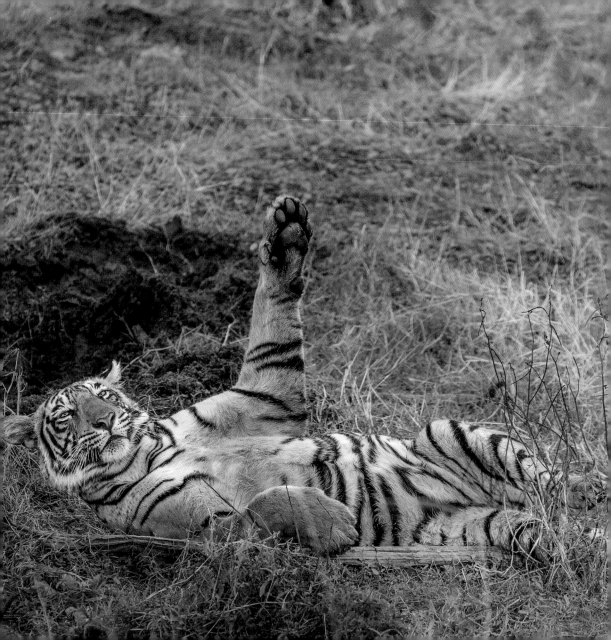

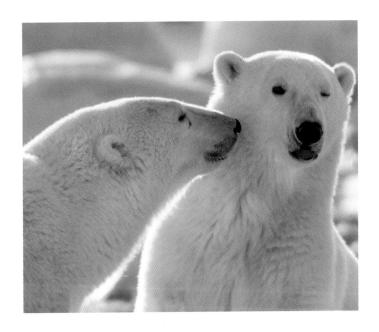

ANIMAL: Polar Bear
LOCATION: MANITOBA, CANADA
I'm not kissing you – we're polar opposites!
PHOTOGRAPHER: Wendy Kaveney

ANIMAL: Asian Tiger
LOCATION: RANTHAMBORE NATIONAL PARK, INDIA
High-five, anyone? Photo-guy? Don't leave me hanging!
PHOTOGRAPHER: Jagdeep Rajpu

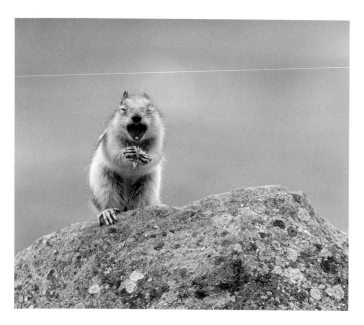

ANIMAL: Ground Squirrel
LOCATION: JASPER NATIONAL PARK, ALBERTA, CANADA
Remembering that hayfever season had just started, Suzy the
squirrel began to regret her choice of wedding flowers...
PHOTOGRAPHER: Jamie Bussey

ANIMAL: Least Bittern
LOCATION: CUYAHOGA VALLEY NATIONAL PARK, USA
That moment when you try doing the splits for the first time in years
and it becomes too late to pull out.
PHOTOGRAPHER: Jennifer Beck

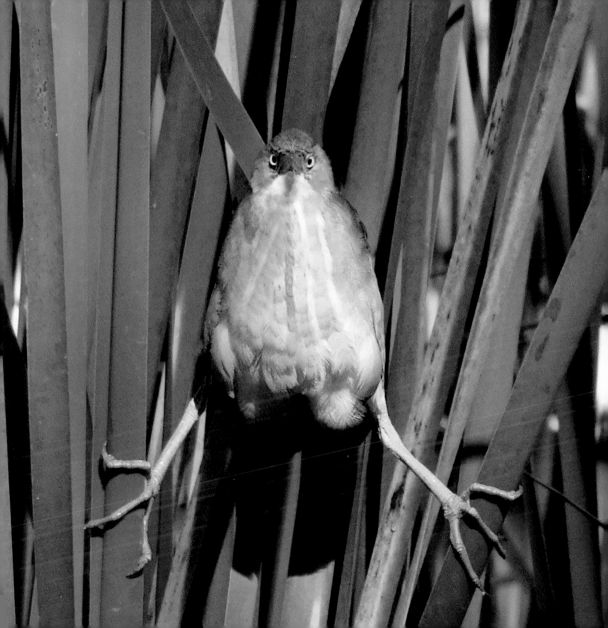

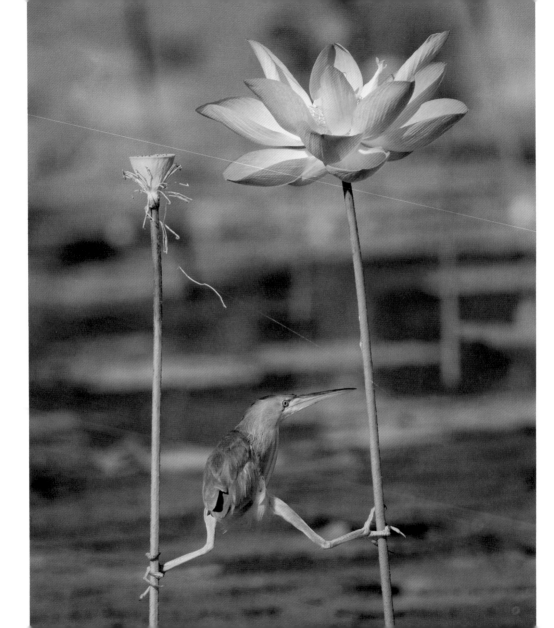

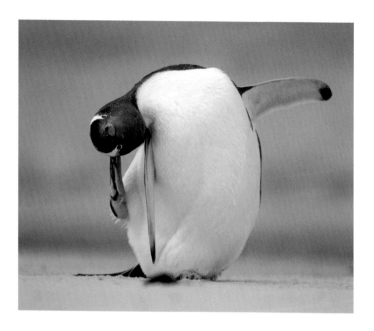

ANIMAL: Penguin
LOCATION: FALKLAND ISLANDS
God, just a little feedback: you could have at least stuck a little itching claw on my pointless flightless wing!
PHOTOGRAPHER: Kevin Schafer

ANIMAL: Yellow Bittern
LOCATION: SATAY BY THE BAY, SINGAPORE
Some folks really go the extra mile to get their partners something for Valentine's Day.
PHOTOGRAPHER: KT Wong

ANIMAL: Leopard
LOCATION: DJUMA PRIVATE GAME RESERVE, SABI SANDS
This leopard is dialling up the cuteness to Puss in Boots from *Shrek* levels.
PHOTOGRAPHER: Lauren Arthur

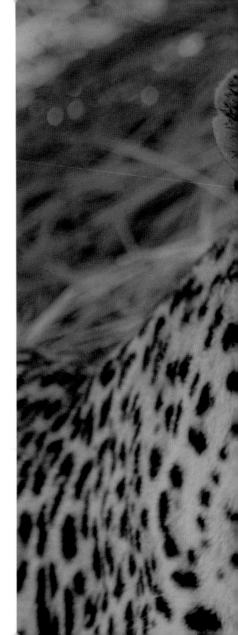

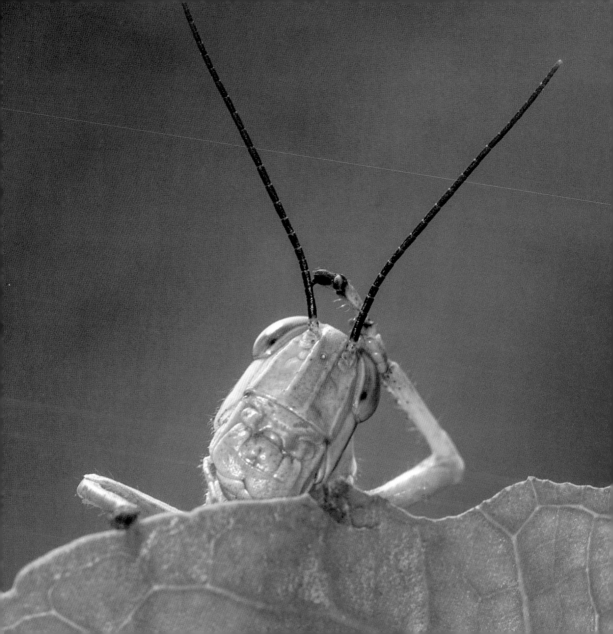

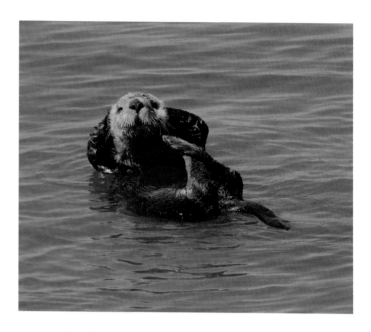

ANIMAL: Sea Otter
LOCATION: MOSS LANDING, CALIFORNIA, USA
It's 5:30pm on a Friday and I'm otter here!
PHOTOGRAPHER: Leslie Scopes Anderson

ANIMAL: Grasshopper
LOCATION: JAKARTA, INDONESIA
If I move my left antenna a little more to the left,
I can pick up Channel 5!
PHOTOGRAPHER: Lessy Sebastian

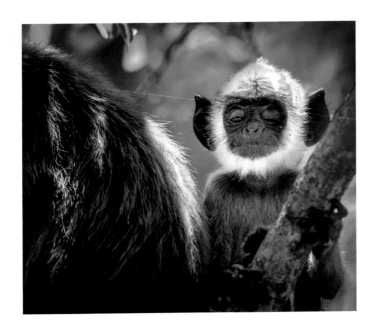

ANIMAL: Monkey
LOCATION: YALA NP, SRI LANKA
I'm actually four years old, but I never get asked for ID
in the off licence.
PHOTOGRAPHER: Michael Stavrakakis

ANIMAL: Bald Eagle
LOCATION: HOMER, ALASKA, USA
Oh you're too kind, yes, it was me on *Life of Birds*!
PHOTOGRAPHER: Margaret Larkin

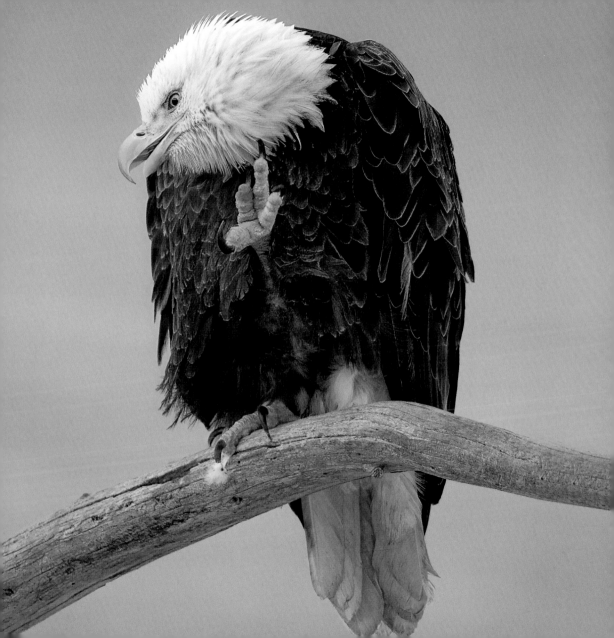

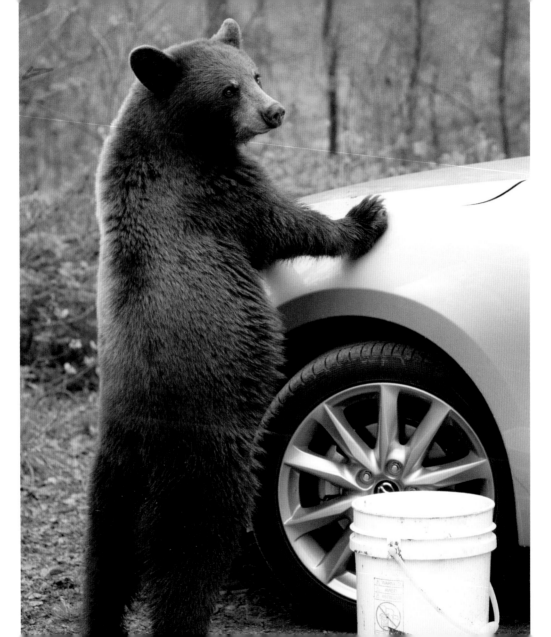

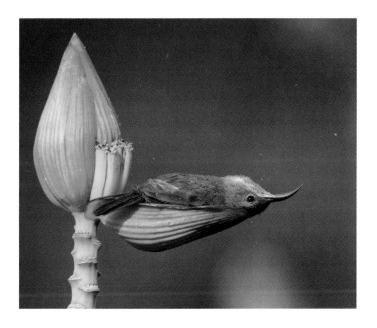

ANIMAL: Crimson Sunbird
LOCATION: COOCHBEHAR, INDIA
In 2022 the banana flower evolved a reclining chair feature for weary sunbirds after their travels
PHOTOGRAPHER: Rahul Singh

ANIMAL: Brown Bear
LOCATION: ORR, MINNESOTA, USA
And this is what'll happen to your car too if you park it on my territory!
PHOTOGRAPHER: Susan McClure

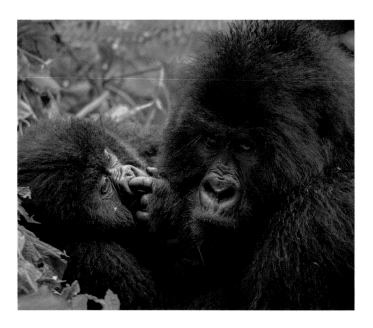

ANIMALS: Baby Gorilla
LOCATION: RWANDA
A quick nose pick while Mum's looking the other way...
PHOTOGRAPHER: Rick Beldegreen

ANIMALS: Indian White-eye Bird
LOCATION: KARNATAKA, INDIA
The Indian white-eye bird is well known for having eyes that are too big for its stomach.
PHOTOGRAPHER: Rajharsha Narayanswamy

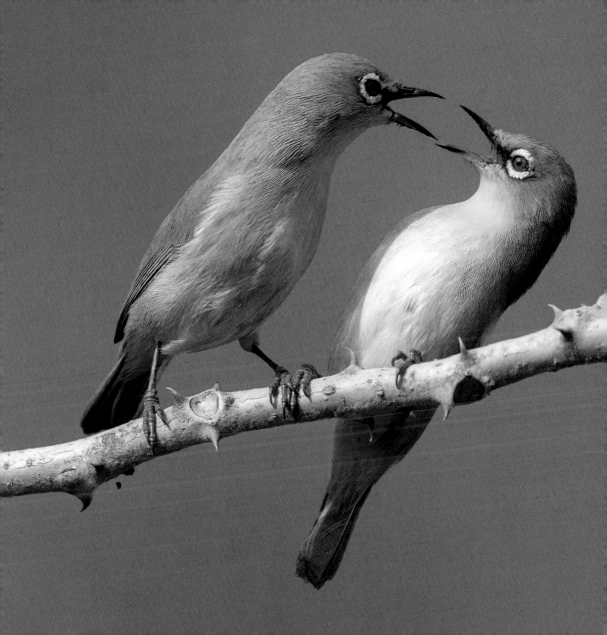

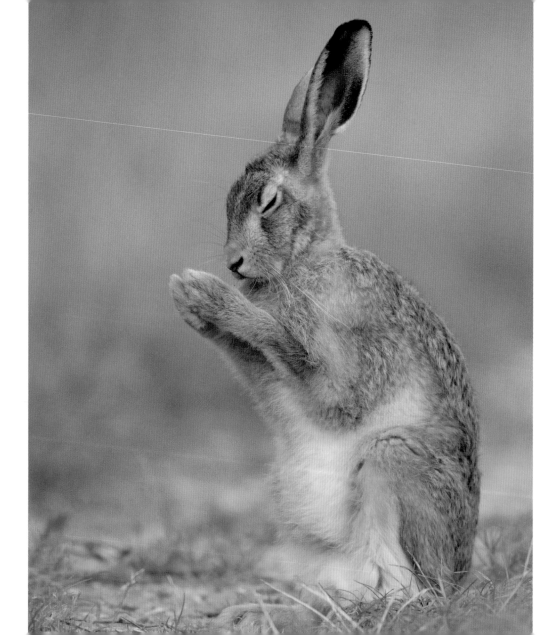

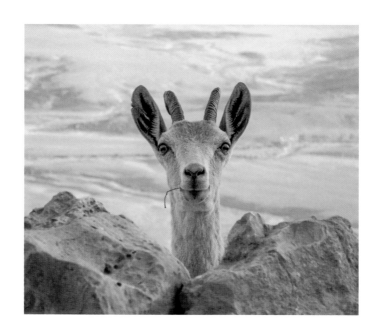

ANIMAL: Ibex
LOCATION: RAMON CRATER, ISRAEL
On reflection, maybe it wasn't a good idea to award the
Bouldering Champion of 2022 a laurel wreath.
PHOTOGRAPHER: Shiko Levi-Champion

ANIMAL: Hare
LOCATION: NORFOLK, UK
For the tasty grass that I'm about to receive, may the Lord make us
truly thankful.
PHOTOGRAPHER: Steve Hatch

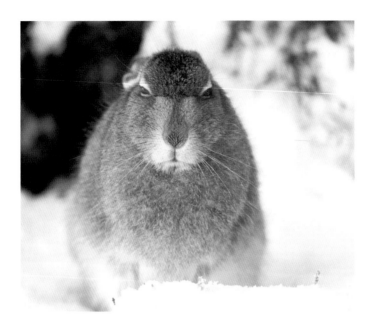

ANIMAL: Hare

LOCATION: CAIRNGORMS, UK

You talkin' to me? Well then, who, the hell else are you talking...

You talking to me? Well, I'm the only one here!

PHOTOGRAPHER: Sophie Bestwick

ANIMALS: African Lions

LOCATION: KENYA

And they say that hyenas have all the fun!

PHOTOGRAPHER: Rose Fleming

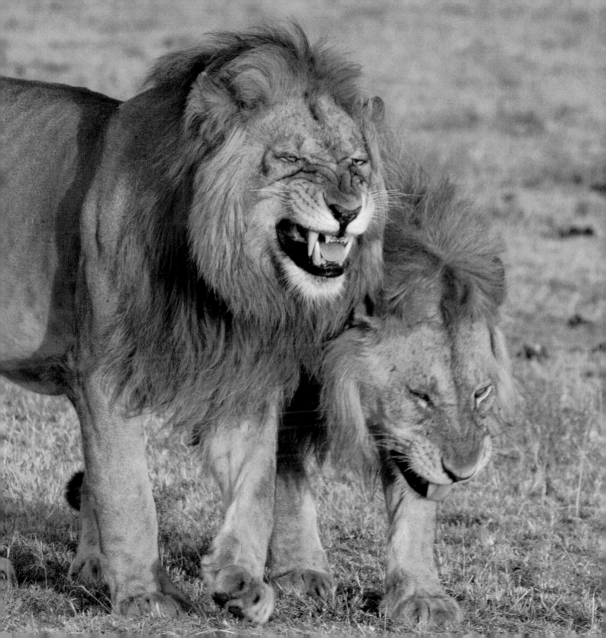

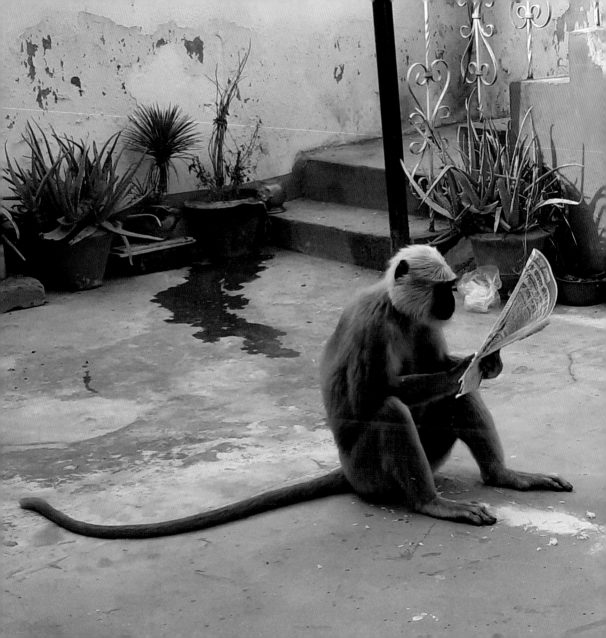

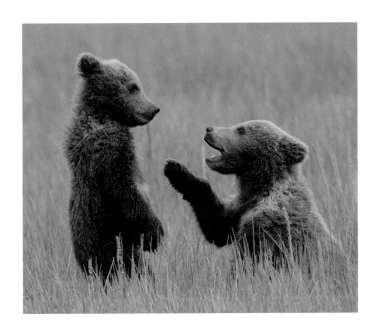

ANIMALS: Brown Bears

LOCATION: LAKE CLARK NATIONAL PARK, ALASKA

Spare half a shekel for an old ex-leper?

PHOTOGRAPHER: Greg Harvey

ANIMAL: Lemur

LOCATION: GORAKHPUR, UTTAR PRADESH, INDIA

Nice to read the paper for a change – most of my news comes via the ape-vine

PHOTOGRAPHER: Hrithik Singh

ANIMALS: African Elephant and Rhino

LOCATION: ETOSHA NATIONAL PARK, NAMIBIA

In a second, you can just tell this naughty elephant's going to look up all surprised and pretend that it's suddenly started raining.

PHOTOGRAPHER: Valentino Morgante

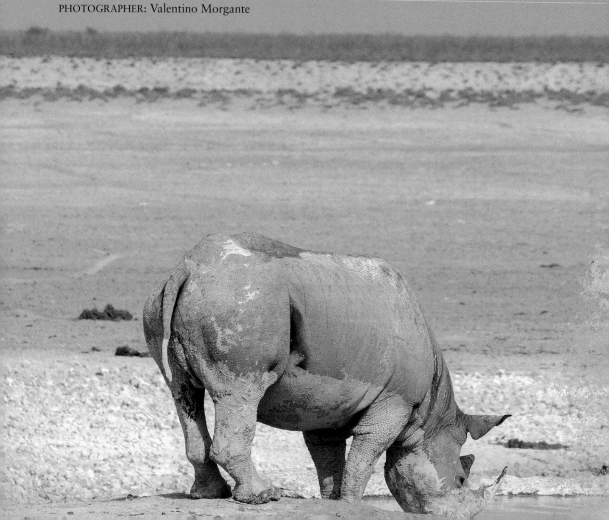

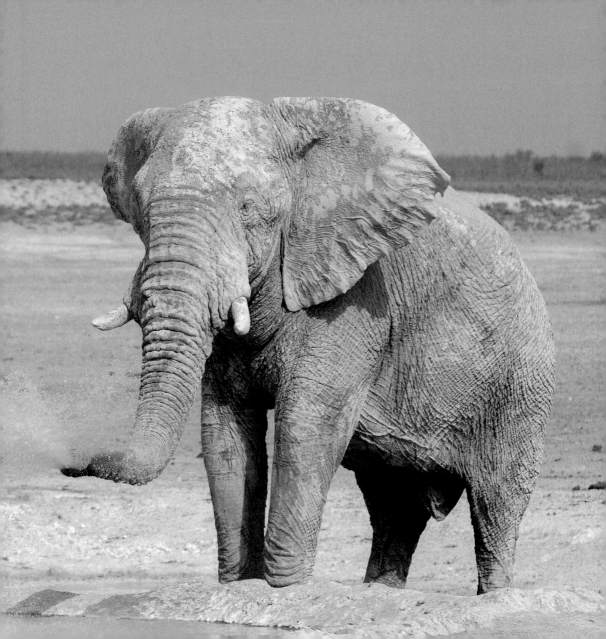

OUR CONSERVATION MESSAGE

Wouldn't it be incredible if we didn't have to write this bit? Imagine a world where habitats and eco-systems flourished, where animal species that were previously endangered were thriving and where oceans were clean of plastic and pollution. Sadly, we still must imagine much of this but, and this is a very big BUT…by doing a few simple things every day, we can start to make a difference. The little steps add up to big steps that turn into big strides and then finally we can make the huge leaps needed that will help us help the planet. Spread the word, tell your children, tell your parents, and let's all move in the right direction together. With that thought in mind, we have teamed up with the clever lot at Whitley Fund for Nature and come up with some useful tips for you all (and for us) to make those first tottering steps:

- *If you're lucky enough to have a garden or a driveway, let it be wilder. Everything – the bugs, the birds, and your sore back – will benefit from our outdoor spaces being a bit messier. Even a window box or two can help the pollinators of this world, so no excuses!*
- *Shop responsibly – avoid unsustainable palm oil products and un-recyclable products and packaging. Buy the cucumber that's not wrapped up and choose the paper bag, or the long-life bag instead of the plastic bags on offer. Or even better, grow your own veg – some varieties are really easy and taste delicious – so give it a go!*
- *Check what activities your bank is funding, using your savings or pension: do they include deforestation, fossil fuels or arms? Make sure the returns are healthy for you and the planet.*
- *Keep an eye on how much water you use; consider a rain collection system, have shorter showers, and maybe forget about baths altogether?*
- *Travel responsibly – could you drive less and walk/cycle/jog more?*
- *Engage with organisations like Whitley Fund for Nature, who are helping conservationists around the world to protect wildlife, restore ecosystems and make life better for people, too. How? Follow them on social media @WhitleyAwards, sign up to their newsletter at www.whitleyaward.org, and support them financially if you can.*

ACKNOWLEDGEMENTS

It is with the utmost pleasure that I get to write this little bit. Sometimes Tom's jokes can wear a bit thin, if you can understand them that is…thin like a hungry stick insect on a thin leaf on the thinnest tree… So here goes. I always have the feeling that I'm standing at the Oscars thanking everyone, the difference being A. No one will ever really read this and B. I promise not to make any jokes about hair or movies, although that would give Tom an excuse to give me a whopping smack, hmmm!

This is how Comedy Wildlife works; me and Tom (me being Paul) have loads of fun looking at funny pictures, chatting to judges and doing the odd video (very odd) and at HQ (yes, we have a head office, no flag yet, but working on it), we have Michelle. The likelihood is you will have e-met her if you have been involved with us in any way; she is unbelievably efficient, fun, inspired, works super hard the whole time, is incredibly tolerant of us (mostly), kind, lovely, funny and generally brilliant. Without her, we are a ship without a sail, a tree without roots, a bird without wings – you get the picture. Mich, THANK YOU. You da best.

Next up, a humungous thank you to all our awesome judges; the list is like a *Who's Who* of Funny Animal Photo Competition judges (well it is). Kate Humble, who is a constant support, encourager and networker for us, thank you, Blossom, Hugh Dennis (legend of TV and radio comedy), Daisy Gilardini (what a photographer), Russell Kane (awesome comedian), Tim

Laman (another photo legend), Luke Inman (underwater super human), Bella Lack (inspiring yoof campaigning for conservation), Will Burrad-Lucas (not only an inspiring photographer but also a legend of photo-preneurship – see what I did there), Will Travers (a leader in global conservation and all round top fella), Ashley Hewson (the top banana at brilliant Affinity Photo), Celina Dunlop (a legend in journey circles around the world), Andrew Skirrow (without a doubt the most decent human being in the website development world) and Simon Pollock (who knows what's what when it comes to fantastic camera bags at Think Tank).

As you can imagine (still no slap yet, I'll keep going), we rely a lot on the brilliantly inspired sponsors who think we are just the bomb when it comes to photo competitions. A massive thanks to you all, we really, really appreciate (I bet the editors cut out my second 'really'… sigh) your partnership with us, it's fun and productive and we are going to change the world, thank you to Alex Walker's Serian for the awesome prize, Amazing Internet, Affinity Photo, Spectrum Photo and Think Tank.

We also want to give a huge thanks to Whitley Fund for Nature for coming on board this year. It is an exciting and symbiotic relationship, and we are super excited about what the future holds. Together we can change the world!

Almost finally we want to say thank you to Ciara and the awesome team at Bonnier for putting together this fabulous book, which will hopefully spread fun and happiness everywhere!

Lastly, and this is from the entire team (OK, that's me, Tom and Michelle), we want to say thanks to our awesome families for being with us through the fun and sometimes mad times of Comedy Wildlife. Without your support, love and endless patience, we couldn't do anything, thank you. Love you all madly.

Much love and happiness to you all,
Paul, Tom and Michelle

ABOUT THE TEAM

PAUL JOYNSON-HICKS is a wildlife photographer, recently 'award-winning' to his great relief, although Tom still out 'awards' him, much to his delight. He lives in Arusha, Tanzania with his Mrs, (aka The Pooch) and his two small boys (aka the Bograts), and his Springers. He loves being in the bush and taking pictures. He was awarded an MBE for charitable work in East Africa over the last 25 years. He created the Comedy Wildlife Photography Awards to give Tom a chance to shine.

Having spent the first part of his professional life working in financial services in London, TOM SULLAM realised the error of his ways to quit everything, pursue a career in photography. Much to Paul's annoyance, Tom then won the prestigious Fuji Photographer of the Year award, along with the One Vision prize and then turned his hand to commercial photography. Having lived in Tanzania (where he met Paul) he now lives on the Hampshire/Surrey borders, with his family, a new puppy and a feline legend called Slinky.

MICHELLE WOOD is not a photographer but has spent much of her life researching and commissioning art and photography for many different projects. She lives with her family in the Oxfordshire countryside, in the house she grew up in....perfectly situated between The Cotswold Distillery and Hook Norton Brewery. Nope, we wouldn't move either!

IN PARTNERSHIP WITH THE
WHITLEY FUND FOR NATURE

Comedy Wildlife are proud to support the Whitley Fund for Nature (WFN), a UK charity working with wildlife conservationists who are collaborating with communities in their home countries across the Global South. Over 29 years, WFN has fundraised and channelled £20 million to more than 200 conservationists in 80 countries. They find, recognise and fund grassroots changemakers leading local solutions to the global biodiversity and climate crises, who are acting on the latest science and igniting projects with passion. In addition to their flagship annual Whitley Awards, WFN also offers repeat funding so that successful conservation solutions can be scaled up with long-term benefits to wildlife, landscapes and people.

We are incredibly chuffed to be working with them raising awareness of the work of the Whitely Award winners and spreading the message that we can all make a difference to conservation.

To find out more and get involved go to: www.whitleyaward.org

Fast, smooth and powerful, Affinity Photo pushes the boundaries for professional photo editing on Mac, Windows and iPad.

Think Tank Photo is a group of product designers and professional photographers focused on studying how photographers work and developing inventive new carrying solutions to meet their needs. By focusing on speed and accessibility, we prepare photographers to "Be Ready Before the Moment," allowing them to document those historic moments that reflect their personal visions and artistic talents.

SPECTRUM ▦
WWW.SPECTRUMPHOTO.CO.UK

Spectrum is a longstanding professional imaging lab specialising in high quality fine art and photographic printing, as well as archival mounting.
www.spectrumphoto.co.uk

ALEX WALKER'S SERIAN

Alex Walker's Serian is a charismatic collection of exclusive and intimate safari camps in the prime wildernesses of Kenya and Tanzania. We operate and outfit safaris, and our focus is on offering you access to the magic of the bush in a rich variety of ways. www.serian.com

ai amazinginternet

Amazing Internet is a leading provider of websites for photographers and other visual artists. Creators of the original and best template-based website system for photographers: portfolioseries.co.uk

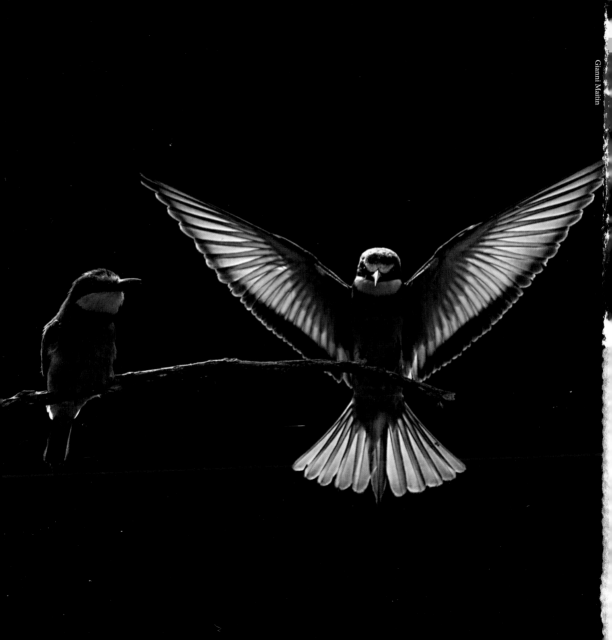